IMAGES
of America

SACRAMENTO'S
CURTIS PARK

IMAGES
of America

SACRAMENTO'S
CURTIS PARK

Dan Murphy

Published by Arcadia Publishing
Charleston SC, Chicago IL, Portsmouth NH, San Francisco CA

Printed in Great Britain

Library of Congress Catalog Card Number: 2005929122

For all general information contact Arcadia Publishing at:
Telephone 843-853-2070
Fax 843-853-0044
E-mail sales@arcadiapublishing.com
For customer service and orders:
Toll-Free 1-888-313-2665

Visit us on the internet at http://www.arcadiapublishing.com

CONTENTS

ACKNOWLEDGMENTS

A book like this could not be completed if there were no Sacramento Archives and Museum Collection Center (SAMCC). Thanks to our city and county for establishing and funding this irreplaceable resource. Thanks also to the SAMCC staff who helped me, especially to Patricia Johnson, Dylan McDonald, and Kevin Morse. Our other great local history treasure is the Sacramento Room of the Sacramento Public Library. Thanks to the Sacramento Room staff, especially to Ruth Ellis and Tom Tolley for their encouragement and unflagging good humor.

Thanks also to the many that live or have lived in Curtis Park and shared their pictures and their stories. I thank all of those who are listed in the photograph credits on the pages that follow and all of those whose took the time to help who are not so listed. The generosity of the Curtis family descendants, Curtis C. Cutter, Caramay Carpenter, Curtis Sproul, and Brooks and Ione Cutter, with their time and materials has been extraordinary.

I thank my fellow members and associates of the Sierra Curtis Neighborhood Association Heritage Committee for their help and their encouragement. Special thanks to members Janice Calpo, for architecture advice, and to Harlene Barrett, Susan MacCulloch, Carl Burke, Don Conner, and Kathy Les. Thanks to Professor Lee Simpson and to Carol Roland for their professional historian help. Thanks to Marc and Beverly Brown for coming to my aid with a laptop for scanning, and to Marc for asking the question "where did it all start" that launched my research. Last, but never least, thanks to Ellen Peter, my spouse, for patiently correcting my drafts. I acknowledge the errors that doubtless remain are my own, and I hope they are few enough to avoid distracting the reader.

INTRODUCTION

I call Curtis Park the area of the Sierra Curtis Neighborhood Association. It is bounded on the north by the W/X Freeway, on the east by Highway 99, on the south by Sutterville Road, and on the west by Freeport Boulevard—until the railroad crossing at Fourth Avenue, then by the railroad line.

The story begins with the early 1850s and proceeds in mostly chronological order. There were three periods of development of suburban neighborhoods. As described in the foreword of the National Park Service's *Historic Residential Suburbs*, "[S]uburban neighborhoods possess important landscape characteristics and typically took form in a three layered process: selection of location; platting and layout; design of the house and yard." An "organizing framework" for any suburban history is the effect of advances in transportation technology and infrastructure on the landscape. The horse, buggy, and wagon gave way to the train and trolley, which in turn were displaced by the car and truck. Each transition has left traces in the landscape.

The landscape characteristics in Curtis Park shift every few blocks. The most prominent shift occurs on an east/west line running from the alley off Twenty-first Street north of Third Avenue, along the north side of the Twenty-fourth Street Theatre, and down Castro Way to Highway 99. This is the Sutter grant line, the boundary marking the Mexican government's land grant of New Helvetia to John Sutter. Legal title north of the line is derived from Sutter. South of the line, ownership passed to the United States in 1846 upon acquisition of California. Legal title then passed under homestead laws or by direct or indirect sale.

Generally the housing stock gets younger as you move south, away from the original city of Sacramento. However, the progression is not smooth. There is a mosaic composed of residential subdivisions laid down during the three periods of development.

The mosaic is derived from the original tracts of ownership, the farms and ranches of the early settlers. The framework for the mosaic is the rough trapezoid formed by early wagon and stage roads. These are shown in the map on the following page. The base of the trapezoid, running east and west, was a road, now Sutterville Road, connecting the early towns of Sutterville and Brighton. Roads running from Sacramento to Stockton, now Franklin Boulevard and Twenty-first Street/Freeport Boulevard, were the sides of the trapeziod. The top was the city limit at Y Street, now Broadway. In the early 1850s, the settlers carved up the trapezoid. The division of their parcels resulted in the present landscape.

The farms and ranches persisted until the late 1880s. A growing city population, a real estate boom, and a transportation innovation, the streetcar, led to the first of three periods of residential subdivision development.

Our first subdivision, Highland Park, starts on the southern border of the original city grid and runs five to six blocks south. The Highland Park subdivision map was filed in September 1887, a month after the Oak Park subdivision map. These were late-19th-century streetcar suburbs. Horse-drawn, cable, and later electric-battery streetcars made it possible to commute to downtown without the inconvenience and stabling expense of a horse or horse and buggy.

After the turn of the century, a second phase of subdivision began. This was enabled by the overhead wire electric streetcar line pushing south from the city. It ran out Twenty-first Street through the center of Curtis Park. Another spur was the location of the shops for the new Western Pacific transcontinental rail line in Curtis Park. A cascade of California bungalow streetcar subdivisions across the top and middle parts of Curtis Park resulted. The looming threat of World War I put a halt to this phase.

Soon after the armistice, the third period began, continuing throughout the Roaring Twenties. Though the streetcar continued to run, the dominant transportation technology was now the automobile and truck. A series of early automobile subdivisions were rolled out. Garages with driveway strips replaced the alleys and carriage houses. These subdivisions filled in the undeveloped patches of Curtis Park. New elementary schools, the junior college, and the dedication of William Curtis Park fostered this growth. The end of available land and the Great Depression brought a halt to residential development.

Since that time, the significant modifications to the landscape have been nonresidential. Changes in transportation have played a role in these events. In the late 1940s, the streetcar system was removed. The construction of the Department of Motor Vehicles headquarters complex in the early 1950s removed most of the Highland Park houses. In the 1960s, the W/X and Highway 99 freeways carved and walled the north and east borders.

Transportation change is an influence in recent events. The automobile arteries have clogged. Long commutes and changing attitudes have renewed appreciation of the charm of the neighborhood's housing stock. The vanquished streetcar has been reincarnated as the light rail alongside the Western Pacific line, now the Union Pacific. The closing of the railyard shops and soaring land values have led to the first new residential development proposals since the 1920s.

The following chapters will trace some of the events and introduce a few of the personalities who have played a role in the history of Curtis Park.

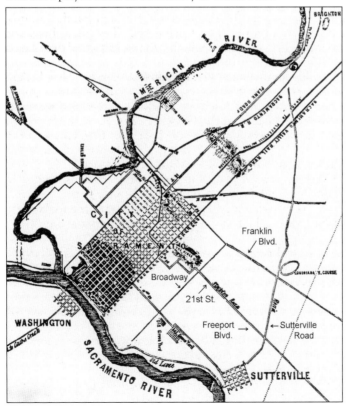

This is an 1855 map of the City of Sacramento and vicinity. Added are some present-day street names. The nucleus of the Curtis Park neighborhood is the trapezoid below the city and to the right. The early roads formed natural dividing lines for the farms and ranches. (Courtesy of the Sacramento Room.)

One

FARMS AND RANCHES

William Curtis, for whom Curtis Park is named, was a Massachusetts native. He was 21 years old when he arrived in California in May 1852. In Sacramento, he visited the homestead of his brother. The homestead house was on the west side of Lower Stockton Road (Franklin Boulevard), at present-day Montgomery Way. (The next page has a map of the farms and ranches.) In 1854, William Curtis became the owner of his brother's 200-acre homestead.

The owner of the property to the north of the Curtis homestead, up to the Sutter grant line, was "Uncle Billy" Richards. A native of England, he came to California in 1850.

The owners of the property to the south of Curtis were Thomas and Mahala Moor. The Moors were New Yorkers who crossed the plains in a wagon, arriving in California in 1854. Their ranch included Whiskey Hill. Whiskey Hill derived its name from the saloons on the corners of Lower Stockton Road and Whiskey Hill Road (Sutterville Road).

To the west of the Moors and Curtis was the ranch of Thomas and Sarah Edwards. Thomas was a native of Wales, Sarah a native of Massachusetts. They raised hops and tobacco. Their house was at what is now 3225 Freeport Boulevard, the present site of the Eskaton Monroe Lodge.

North of the Edwards, the land bordering Curtis and Richards belonged to New Yorkers Moses and Nancy Sprague. Moses arrived in 1852 via wagon train. In 1854, Nancy joined him. Sandwiched between the Spragues and the Edwards were 30 acres of the Brockway farm. Charles Brockway, also a New Yorker, had occupied the 190-acre farm since 1851. He and his wife, Elizabeth, had one son and four daughters. They cultivated hops and fruit. Charles was a ferryman as well as a farmer.

North of the Sutter grant line, less is known about the earliest uses of the land. The 20-acre parcel at the southeast corner of what are now Broadway and Twenty-first Street was acquired in 1864 by the congregation of St. Rose's Church for use as St. Joseph's Cemetery.

Another parcel made up of three blocks to the east of St. Joseph's, running all the way south to the grant line was owned by M. M. Odell and his son M. F. Odell. They used it as a stockyard and slaughterhouse.

In September 1855, the first historical neighborhood event was the racing and livestock exhibition portion of the second California State Fair. It was held at the Louisiana Race Course, in the vicinity of the southeast corner of present-day Sutterville Road and Franklin Boulevard intersection.

On July 21, 1870, according to the *Sacramento Daily Union* (hereafter *Union*), "Uncle Billy" Richards "was thrown from his buggy at the corner of Eleventh and J Streets, in consequence of the breaking of one of the wheels, and was precipitated into the hole on the southeast corner of the street, which formerly was covered by the sidewalk in front of the Haines Exchange Hotel, recently destroyed by fire." He died at his ranch five days later.

On July 5, 1871, James Clarence "J. C." Carly, who become our predominant real estate developer, was born in the family home on Sixth Street between N and O Streets.

On July 12, 1871, "Uncle Billy" Richards's ranch, divided up into six parcels of about 10 acres each, was auctioned in the parlor of his home. August Heilbron bought four of the parcels. He bought another one a little over a year later.

On June 7, 1877, Thomas Edwards, age 62, died. As a result, the Edwards property was partitioned into several parcels after litigation between his heirs.

On March 31, 1884, Charles Brockway Sr. died. His wife, Elizabeth, received the Curtis Park portion of their property including the family home.

The 1880s was the period of the first real estate boom in California. The extension of the railroads to Southern California, the introduction of citrus crops, and the developing markets for fruit, all contributed to a swelling population. The northern and southern parts of the state engaged in a rivalry for immigrants. Sacramento was the hub of a railroad network extending throughout Northern California and connecting to the transcontinental Central Pacific. By 1887, the boom was in full sway in the Sacramento region. The *Union's* headline on August 29, 1887, was "Boom! Boom!! Boom!!!" The paper attributed "the sudden rise in real estate" to the prosperity caused by fruit production, making the region highly attractive to "homeseekers." On September 6, the *Union* headlined another boom in "Street Railroad Franchises." The stage was set for the first significant residential development in Curtis Park.

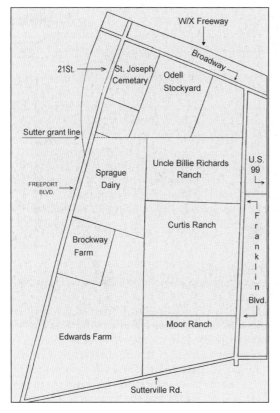

This map of Curtis Park shows the known early ownership and land use. Note the shift at the Sutter grant line from the magnetic north grid of the original city to the true north orientation of the federal government's township and range system. The latter was adopted to facilitate the settlement of the vast western lands owned by the United States. (Courtesy of SAMCC.)

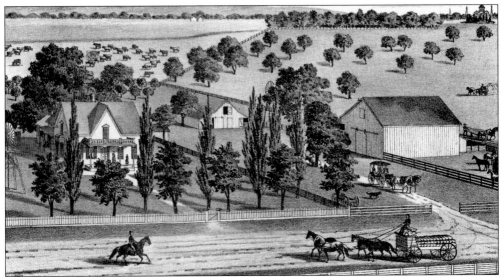

This 1880 engraving from Thompson and West's *History of Sacramento* shows the Curtis Ranch. The Curtis family chose the homesite because it had been a dwelling place of Native Americans. It sat under the large oak on the curb at Montgomery Street until September 1996. Curtis Park's trees have always been important to its identity. (Courtesy of the Sacramento Room.)

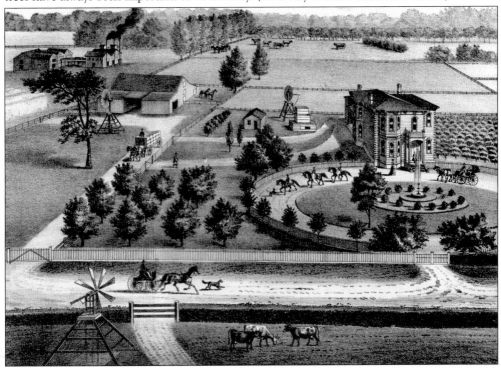

This is the Brockway home on Freeport Boulevard. On the July 4, 1860, Charles Brockway Jr.'s left arm was shattered by a cannon. At an 1861 New Year's Day dance, offended by Thomas Coleman's behavior, he borrowed a knife and stabbed Coleman in the groin. Retreating to the ballroom, Brockway then slashed Patrick Murphy's left shoulder. Brockway was acquitted in two separate trials of charges of assault to murder both men. (Courtesy of the Sacramento Room.)

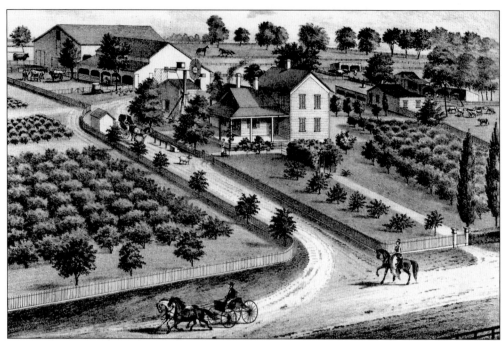

In 1855, the Sprague family relocated from Colusa to this 135-acre dairy ranch. Their house was at what is now Fourth Avenue, near present-day Twenty-first Street. The Spragues had three children: Helen, Frederick, and Hattie. (Courtesy of the Sacramento Room.)

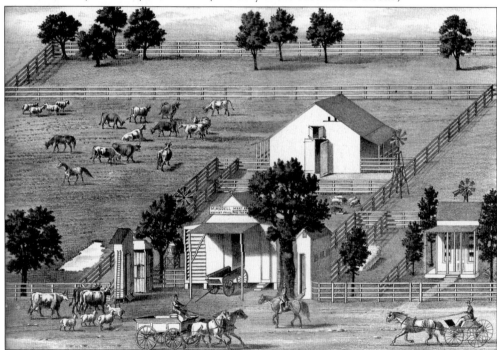

This is the Odell stockyard. In 1861, M. M. Odell moved his family overland to California. He was a cattle trader and butcher, though later in life he listed his occupation in the city directory as "capitalist." (Courtesy of the Sacramento Room.)

The Edwards had four children. Eustace, the eldest, was born in Massachusetts. The rest of the children, Benjamin, George, and Sophia, were born in California. Sophia Edwards ultimately inherited the biggest part of the Edwards property. This photograph, c. 1940, shows the house of Sophia Edwards Gay built in the 1860s. (Courtesy of SAMCC.)

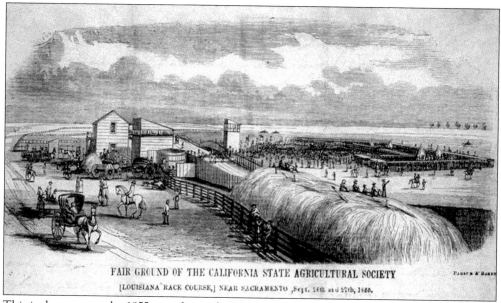

FAIR GROUND OF THE CALIFORNIA STATE AGRICULTURAL SOCIETY
[LOUISIANA RACE COURSE,] NEAR SACRAMENTO ,Sept. 26th and 27th, 1855.

This is the scene at the 1855 state fair at the Louisiana Race Course. By 2:00 p.m. on September 28, 1855, "every vehicle and animal [in Sacramento] was en route for the race course. At this hour, it is not an exaggeration to say that there was an unbroken line of stages, wagons, carts, sulkys, barouches, equestrians and pedestrians extending all the way from the Orleans Hotel to the fairgrounds, a distance of three miles." One spectator, Abram Irving, was gored by a bull and died. Another person was stabbed in the kidneys with a bowie knife, but survived. (*Union* photograph courtesy of the Sacramento Room.)

William Curtis's trip to California had a slight detour. He left from New York on the steamer *Prometheus* in early February and crossed the isthmus at Nicaragua. He embarked there on the steamer *North America* for San Francisco. One night, the vessel shipwrecked. Fortunately the *North America* was able run ashore about 90 miles south of Acapulco. Curtis made it to Acapulco by pony and then to San Francisco by another sailing vessel. (Courtesy of Curtis Carly Cutter.)

In March 1866, Pres. Andrew Johnson signed this preemption certificate, No. 1460, granting William Curtis's claim to the 159.92-acre homestead. The Richards, the Spragues, the Brockways, and the Edwards all obtained preemption certificates around this time. (Courtesy of Curtis Sproul.)

On January 1, 1862, Curtis married Susan Willis Potter of Ione Valley. Born in Massachusetts, she came across the plains to California in 1853 with her parents. She was 10 years old. (Courtesy of Brooks Cutter.)

In 1863, the Curtises had a son, William Jr. In 1880, at the age of 17, he died. He bled to death after a scything accident at the ranch. In November 1870, a second son, Frederick Curtis, was born. He lived only four years and four months, dying of illness in 1875. (Courtesy of the Brooks Cutter.)

In 1865, the Curtises had a daughter, Carrie. With the exception of a brief sojourn in East Sacramento, Carrie lived in Curtis Park her whole life, until 1957. (Courtesy of Brooks Cutter.)

In February 1878, Alice Curtis, the fourth child of William and Susan, was born. Alice lived until 1902, when she died in San Francisco. Her remains were brought back to Sacramento and interred in the family plot a year later. (Courtesy of Brooks Cutter.)

This deed of November 11, 1882, transferred title of the Moor ranch to William and Susan Curtis. This gave them ownership of the entire southeastern portion of the Curtis Park trapezoid. (Courtesy of Curtis Sproul.)

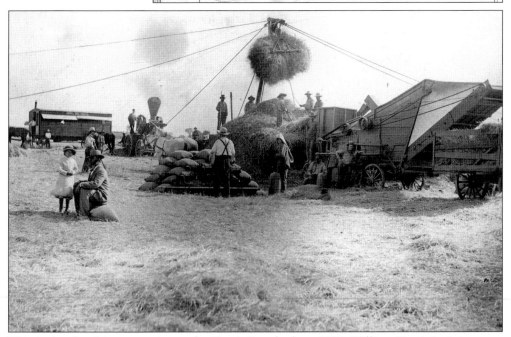

This is the threshing operation at the Curtis Ranch about 1870. William Curtis is sitting on a grain bag, Carrie Curtis stands next to him. Curtis also used his equipment to harvest the grain crops of other farms. (Courtesy of Curtis Sproul.)

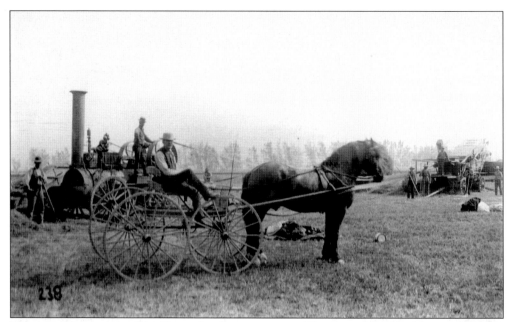

This is another picture of the Curtis threshing operation. The magnificent draft horse appears in other Curtis Ranch pictures. By 1890, William Curtis had 90 horses and 40 cattle in Sacramento, as well as a 1,200-head cattle ranch in Arizona. (Courtesy of Curtis Sproul.)

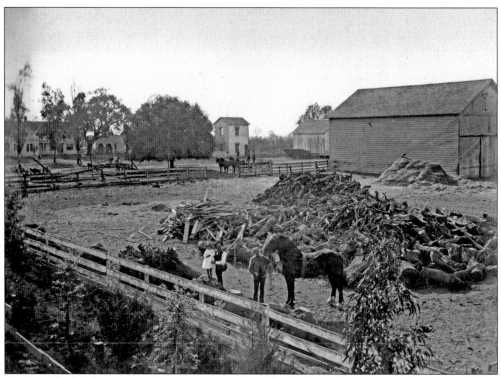

Curtis and a daughter are looking northeast at Franklin Boulevard near present-day Donner Way. (Courtesy of Curtis Sproul.)

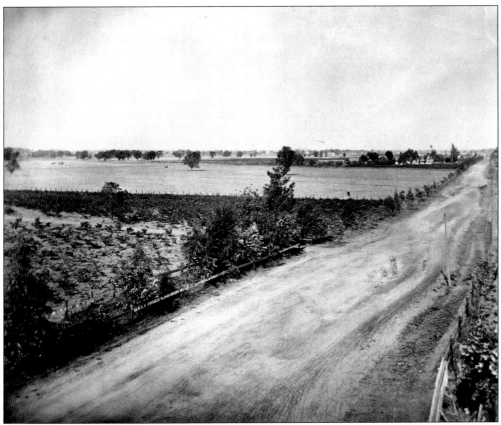

This is a view of the Curtis Ranch about 1885 looking north from about Twelfth Avenue and Franklin Boulevard. The bare-looking patch in the middle was wheat and alfalfa fields. (Courtesy of Curtis Sproul.)

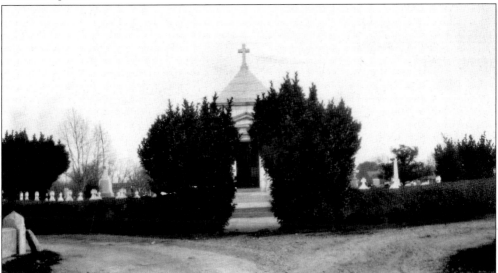

This 1939 photograph shows the landmark center vault of St. Joseph's Cemetery. It is surrounded by the headstones of early priests of Sacramento's churches. (Courtesy of SAMCC.)

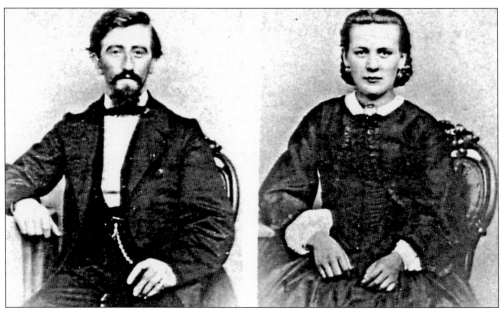

Pictured are August and Louise Heilbron. August and his brother Adolph came to California in 1854 from St. Louis, two years after emigrating from Germany. They were involved in raising stock and butchering. They acquired large real estate holdings in Sacramento and the vicinity. (Courtesy of the Sacramento Room.)

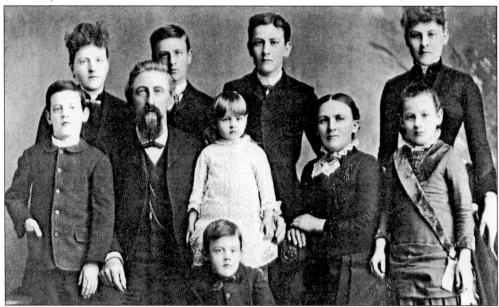

This is a picture of the Heilbron family. After purchasing the Richards place, they promptly moved in. Louise was pregnant, and August worried about leaving her with three small children so far out in the country. Ah Fou, their household servant, threatened to quit because of the isolation. The commute to work and shopping trips by horse and buckboard were inconvenient. In cold and stormy weather, the trips left August wet and chilled to the bone. In late November, August bought the Miller house at Seventh and O Streets, and the Heilbrons moved back to town. (Courtesy of the Sacramento Room.)

Two

HIGHLAND PARK
THE FIRST STREETCAR SUBURB

According to *Historic Residential Suburbs*, "The suburban home first appeared as a rural villa for the fairly well-to-do family in the mid-19th century. Located 'on the edge of the city,' it was intentionally designed as a therapeutic refuge from the city, offering tranquility, sunshine, spaciousness, verdure, and closeness to nature-qualities opposite those of the city. This ideal was aggressively and persuasively articulated through pattern books, the writings of domestic reformers, and popular magazines. As house designs became adapted for more modest incomes and advances in transportation lowered the cost of commuting, suburban living became affordable to an increasingly broad spectrum of the population."

On August 27, 1887, the Lower Stockton Road Improvement Committee met at the Curtis Ranch. According to the August 30, 1887, *Union*, they decided to increase sprinkling of the road and to line its sides with straw to assist the "many thousands of land and home-seekers that now throng our public highways." During the same week, advertisements began to run for a September auction sale of the first subdivision outside the original city grid, Oak Park. During that week, Merrill F. Odell sold the Odell property in Curtis Park to Phillip Herzog for $12,000 in gold coin. Hertzog promptly transferred the property to Frances C. Myers for the same price. Myers, a woman living in Alameda, was described by the *Union* as "an Eastern Capitalist."

On September 13, 1887, the Oak Park auction was conducted. The same day, Myers ran an advertisement for a similar auction sale for "Highland Park"—the Odell property subdivided into 275 lots. The big selling points were the guarantee of a 5¢ per ride street railway connection to downtown within 60 days, high elevation (insuring safety from flood and malaria), wide streets and alleys, and no city taxes.

The name "Highland Park" reassured concerns of potential flooding, since the subdivision was outside the city's south levee. Possible sources for the name "Highland Park" are earlier developments elsewhere. Highland Park of Los Angeles, between that city and Pasadena, was subdivided in 1885. Highland Park near Chicago, or the borough of the same name near Philadelphia, are other possible antecedents, given Myers's "Eastern" origins.

On October 8, 1887, the Highland Park auction was conducted. Fifty-nine lots were sold at an average price of $164. Myers's husband was unhappy with the average selling price. He attributed it to rumor that the street railway would not be delivered. Rumor notwithstanding, the first car had been test run on the K Street line, drawn by four grays, the week before.

By November 1888, all but 30 of the lots were sold, though it is not known how many houses had been built. The area was outside city limits, so there were no building permits and no street address listings in the city and county directories. The Highland Park houses included Queen Anne, Italianate, and folk Victorians, American Foursquare, and Pyramidal bungalows. All have wide front porches as a key element. They often have raised basements, with the front door entry a story off the street level, both from concern for potential flooding and as a prevailing

fashion of the day. The alley platting reflects horse-drawn transportation. Rear service alleys shield unsightly carriage houses and utilitarian activities attending wagon deliveries.

At first, Highland Park developed more rapidly than Oak Park. The 1889–1890 City Directory praises the opening of Central Street Railway System from the Southern Pacific Depot to Oak Park. "The advent of this railway opens up for settlement a large and beautiful residence district, the Oak Park Tract." The directory noted that the Highland Park Railway had been opened "some years ago" and that Highland Park "is fast being built over with elegant mansions, beautiful villas and lovely cottages—making homes in the pure country air for hundreds of Sacramento's toilers." The directory also reported that the Central Street Railway was experimenting with a battery electric motor. By 1891, the line to Oak Park was electric, and Oak Park became the dominant suburban district.

There was no further subdivision development during the Gay Nineties. Outside Highland Park, life and death continued on the farms and ranches. The turn of the century came and went. In 1900, Moses Sprague died and the next year his wife, Nancy, followed. She left the property to Hattie, now Hattie Walton. After a court fight with her siblings that went all the way to the California Supreme Court, Hattie prevailed. The next phase of development was ready to begin

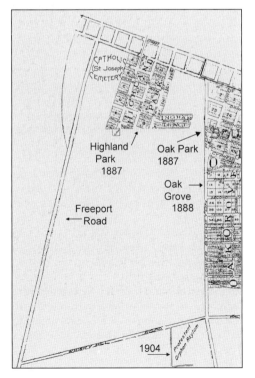

This map shows the portions of Curtis Park that were subdivided and developed first. Oak Park's western border was along Lower Stockton Road (now Franklin Boulevard). A slice of Oak Park and the 1888 subdivision, Oak Grove, to the south, were included in the Curtis Park neighborhood by avulsion in the construction of the Highway 99 freeway. (Courtesy of SAMCC.)

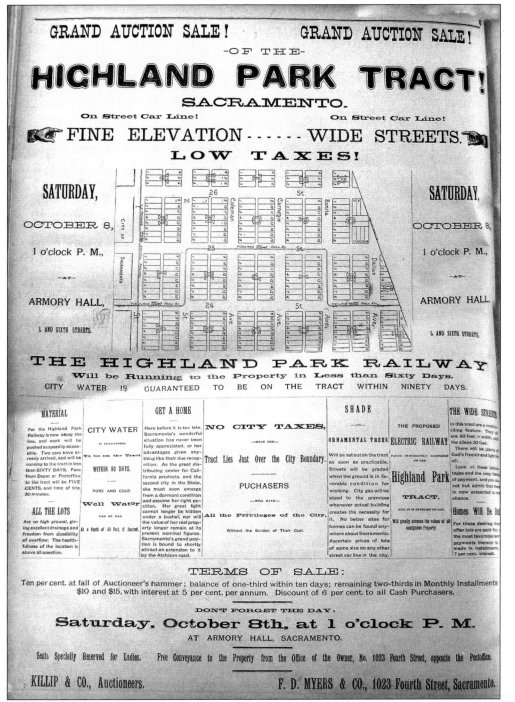

This is the Highland Park auction advertisement that ran in the *Union*. It includes tiny horse-drawn streetcars. Note the promise to plant ornamental trees. Trees, according to John R. Stilgoe's 1988 book *Borderland, Origins of the American Suburb, 1820–1939*, were an essential spiritual element of the American suburban movement. (Courtesy of SAMCC.)

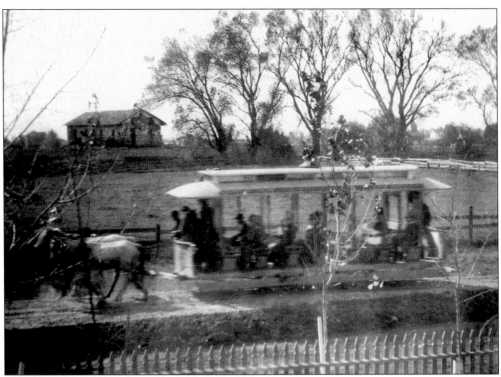

This is a horse-drawn streetcar, *c.* 1880, near Twenty-eighth and L Streets. This was probably the Oak Park line which crossed Curtis Park at Twenty-eighth Street and Broadway. (Courtesy of SAMCC.)

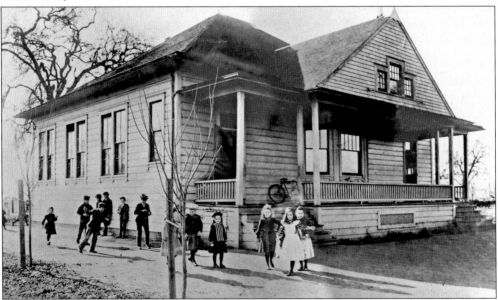

This is a picture of the second Highland Park School, constructed in 1902. The school was across the street from the current Twenty-fourth Street Theater at the Sierra 2 Center. In 1887, Moses Sprague conveyed the land to the school district trustees. (Courtesy of Sacramento County Office of Education Collection.)

Here is a young J. C. Carly. On August 4, 1900, he was standing at Seventh and K Streets when a runaway delivery wagon darted by. In it was a white-faced eight-year-old girl "gazing piteously from side to side, as if imploring help." Carly jumped into a buggy driven by Sheriff McMullen, and they gave chase. When the wagon was turned by a crossing train, Carly jumped aboard, seized the reins, and brought the runaway under control. The girl was unhurt; the "gallant" sheriff threw his left shoulder out of place. (*Union* photograph courtesy of Curtis Sproul.)

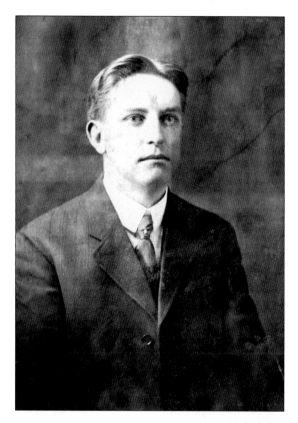

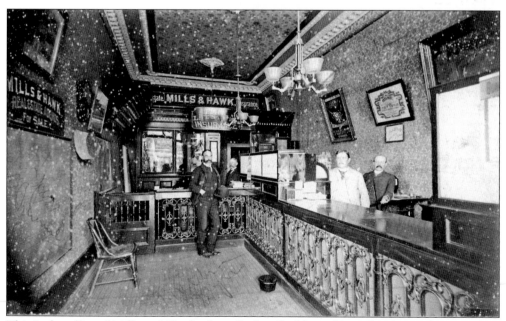

This is the office of Mills and Hawk where Carly talked himself into his first real estate job in September 1871. He had lost his job as a grocery clerk due to hard times and walked into Mills and Hawk looking for work. (Courtesy of Curtis Sproul.)

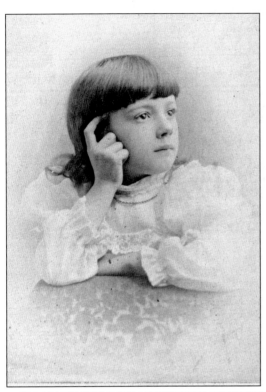

This is William and Susan Curtis's last child, Edna, in the early 1890s. Edna, born in 1884, was one of the two children to survive the Curtis parents and thus inherit part of the Curtis Ranch. (Courtesy of Brooks Cutter.)

This is the marriage license of Carrie Curtis and George Cutter. Cutter was the scion of another early farming family, whose holdings included 40 acres in East Sacramento. (Courtesy of Curtis Sproul.)

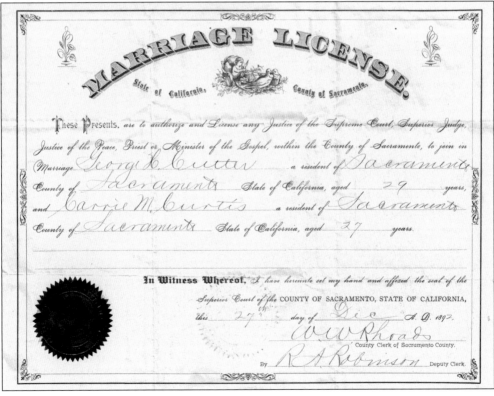

The Cutters pose here with their
baby boy, Curtis Harold Cutter,
born in 1895. He was their only
child. (Courtesy of Curtis
Carly Cutter.)

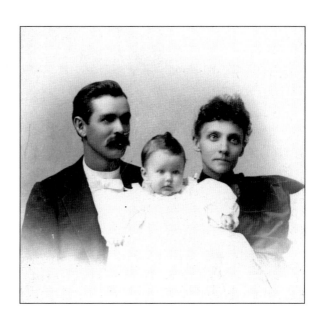

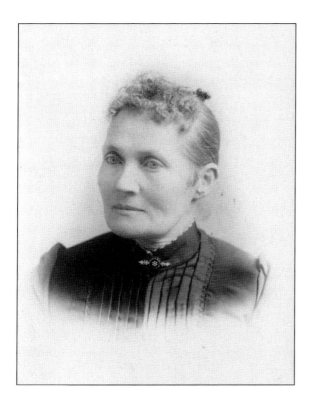

This is Jennie E. (Wells) Cutter,
George Cutter's mother. Jennie came
to California via Panama in 1857, and
married Reuben Cutter a few months
after. George's father, Reuben, died in
1873 when George was nine years old.
(Courtesy of Brooks Cutter.)

WM. CURTIS

(PRESENT INCUMBENT)

Regular
Republican Nominee
...For...

SUPERVISOR

FOURTH DISTRICT

Election: Tuesday, Nov. 6, 1900

SONNE PRINT (TRADES LABEL COUNCIL) 1019 NINTH ST

This card is from William Curtis's reelection campaign for the board of supervisors; Curtis was first elected in 1883. He hired his son-in-law as an aide to administer the building of macadamized county roads. (Courtesy of Curtis Carly Cutter.)

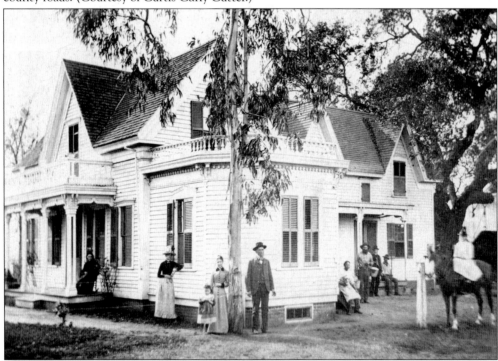

On the porch of the Curtis Ranch house is Susan Curtis's mother. Leaning on the house is Carrie Curtis. William and Susie Curtis stand at the eucalyptus tree with Edna, and Alice Curtis is on horseback. The farm hands are unidentified. The oak behind the house is the Curtis Ranch oak. (Courtesy of Curtis Sproul.)

This portrait is of May Glen and her brother. On October 7, 1896, May married J. C. Carly. Their only child, Leita, was born in November 1897. (Courtesy of Brooks Cutter.)

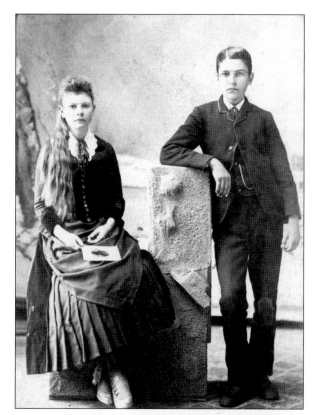

These are the offices of the Hawk and Carly Company. In 1897, the partnership was formed. In 1904, they took in Robert Hawley and became Hawk, Hawley, and Carly Company. (Courtesy of Curtis Sproul.)

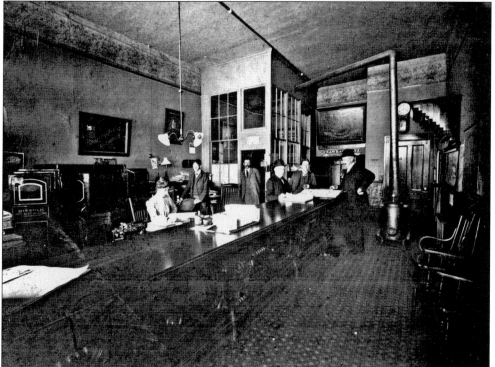

The next several photographs, taken in 1949, are of Highland Park houses, later removed. This photograph shows an 1880s house at 2317 Castro Way. It is I-House style, characteristically two rooms wide and one room deep, two stories high, with a central entrance, and a gable roof. (Courtesy of SAMCC.)

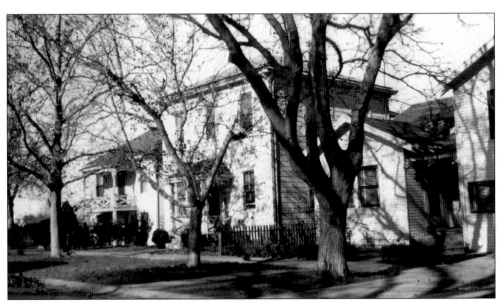

This house, on the north side of Sloat Way and west of Twenty-fourth Street, is built in the Italianate Victorian style. (Courtesy of SAMCC.)

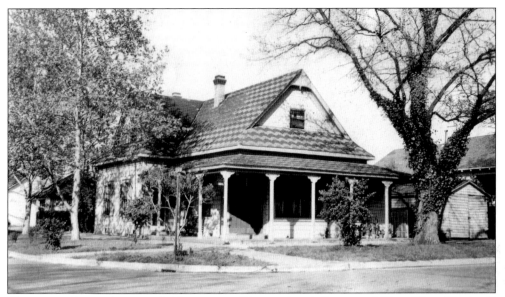

This was a Queen Anne–style Victorian at Twenty-fourth Street and Sloat Way. (Courtesy of SAMCC.)

In the foreground is another Queen Anne Victorian at 2350 Sloat Way, on the southwest corner of Twenty-fourth Street. (Courtesy of SAMCC.)

Curtis H. Cutter and friends enjoy summer recreation at the Curtis Ranch, around 1900. (Courtesy of Brooks Cutter.)

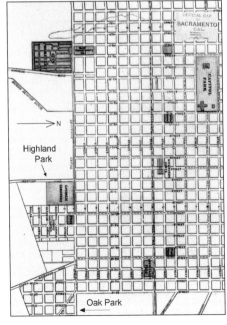

This c. 1900 map shows a portion of Sacramento's street railways. The Twenty-fourth Street car line only penetrated a block into Highland Park. (Courtesy of SAMCC.)

Three

THE
EARLY-20TH-CENTURY
STREETCAR SUBURBS

The next period of suburban subdivision began after the turn of the 20th century. The houses in these subdivisions are predominantly bungalows. The history of the term is explained in Michael Dolan's *The American Porch: An Informal History of an Informal Place* (2002), pages 53-54. Derived from *banggalo*, meaning "of Bengal," bungalows were modeled after an antecedent house style from India. The banggalo was surrounded by a *baranda*, a perimeter overhang supported by poles. In both Hindi and Portuguese, the word for pole is *vara*. Hence, the bungalow comes with a porch, or veranda. As time went on, the bungalows shifted from pyramidal style with raised basements to arts and crafts style. The later movement was, in part, an architectural reaction to the excesses of Victorian embellishment. It was also a social movement, like the recent vogue of simplicity, away from the excesses of industrialization.

In 1904, the first new Curtis Park development was the Twenty-eighth Street Tract west of Franklin Boulevard. This was the sixth parcel of the Billie Richard's Ranch, the one the Heilbrons did not purchase. That same year, the Protestant Orphanage purchased the John Charles Tract across Sutterville Road from the Curtis Ranch. Perhaps most significant that year was the extension of the Twenty-first Street overhead electric car line to Second Avenue and then to Twenty-fourth Street in Highland Park.

In 1905, Susan Curtis died. Automobiles were just beginning to be seen. In 1905, there were 27 autos registered in Sacramento County. By 1910, there were 700 more. The automobile revolution was well underway.

In February 1906, the Western Pacific Railroad announced its proposed route through the City of Sacramento. It would traverse north to south, 80 feet west of Twentieth Street.

In January 1907, William Curtis deeded the northernmost portion of the Curtis Ranch to an agent for investors led by Hawk, Hawley, and Carly for $40,000. The next day the agent granted a right-of-way for a street railway through the middle of the parcel to Sacramento Electric, Gas, & Railway Company. Three days later, the subdivision map for the property, Curtis Oaks, was filed. Two weeks after he sold Curtis Oaks, William Curtis died.

In 1907, Hattie Walton sold the right-of-way across her land for the Western Pacific line. Presumably the other Curtis Park landowners followed suit. In January 1909, Hattie sold her portion of the Curtis Park railyards to P. C. Drescher. He was acting as the agent for a committee

established to obtain land near Sacramento to give to Western Pacific Railroad—in return for locating its main California shops here. Drescher promptly conveyed the land to Western Pacific for that use.

In November 1909, Hattie conveyed her remaining lands in Curtis Park to Hawk, Miller, and Carly. In June 1910, they filed the subdivision map for West Curtis Oaks. In 1911, they added the remaining land north of the railyards as the West Curtis Oaks Addition. The selling point for the development was that it had all the "city improvements," macadam oil streets, cement curbs, gutters, sidewalks, water pipes, and gas lines.

The capstone on suburban progress was the successful 1911 annexation election. In August, the Curtis Oaks Improvement Club met at the first hose cart firehouse on what is now Twenty-seventh Street. The club unanimously voted to support annexation. On September 12, the measure carried 2,698 to 985. The vote at Highland Park School was 125 to 41.

After William Curtis's death, the Curtis Ranch land was split approximately in half. Edna Curtis received the west side and Carrie Curtis the east side. Edna transferred her half to the Hickman-Coleman real estate firm. Hickman-Coleman took preliminary steps to develop their half, grading the land and filing a subdivision map before 1913. However, it was never marketed. J. C. Carly made an agreement to develop Carrie's half around the same time. However, the title was never transferred. Either lack of demand or the coming world war put the damper on further development.

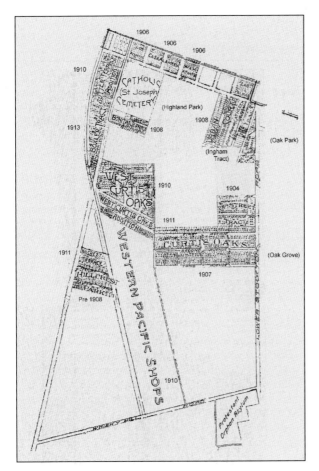

This map shows the subdivisions developed from 1904 to 1913. The catalyst was the advance of the electric streetcar line through the heart of Curtis Park. (Courtesy of SAMCC.)

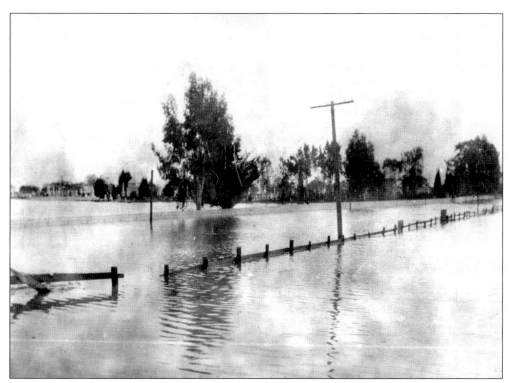

This 1904 photograph looks south from Twenty-first Street and Y Street (now Broadway). Just to the left of the trees in the foreground is the priests' vault in St. Joseph's Cemetery. Highland Park houses are on the horizon. According to the February 29, 1904, *Sacramento Bee*, "The water worked in back of Highland Park adjoining St. Joseph's Cemetery, but it never reached a depth sufficient to cause more than slight inconvenience to the residents of that suburb." (Courtesy of SAMCC.)

Here is Susan Curtis next to the Curtis Ranch house. She was 62 when she died in 1905. (Courtesy of Curtis Carly Cutter.)

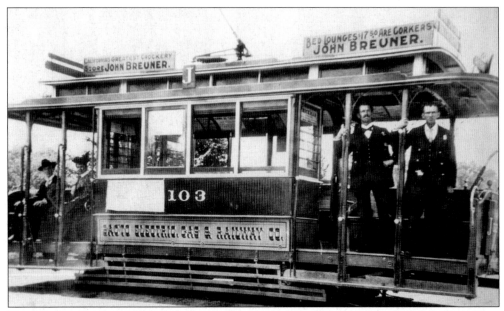

This is an overhead wire electric streetcar of the Sacramento Electric, Gas, & Railway Company. Early motormen carried sledge hammers to pound down loose spikes and rail ends. This was called "pounding down the snake heads." (Courtesy of SAMCC.)

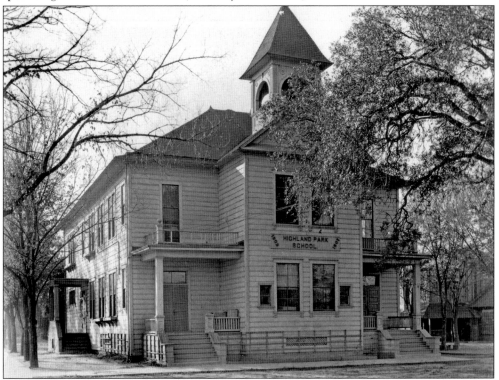

This is Highland Park School as rebuilt in 1907. It was used until 1933. Slated for demolition, it burned down on April 26, 1935. A crowd of 10,000 gathered to watch the conflagration. (Courtesy of SAMCC.)

In 1907, J. C. Carly and his horse, Old Dan, pose in front of the Curtis Ranch house. (Courtesy of Curtis Sproul.)

This is a north view up Franklin Boulevard from about Fifth Avenue in 1907, before development of Curtis Oaks. (Courtesy of Brooks Cutter.)

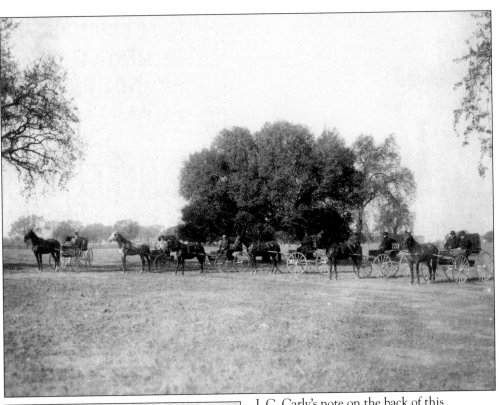

J. C. Carly's note on the back of this photograph says: "Our rigs taken at Curtis Oaks just before subdividing." Depicted, among others, are Carly, Howard Kerr, Thomas Coulter, and Robert Hawley. Perhaps they were investors in the development. (Courtesy of Curtis Sproul.)

PRICE LIST OF UNSOLD LOTS IN

CURTIS OAKS

HAWK, HAWLEY & CARLY CO.

823 JAY STREET SACRAMENTO, CALIFORNIA

2	$465	97	$650
4	$465	98	$650
5	$485	124	$710
7	$525	125	$750
8	$500	137	$650
12	} $1200	139	$625
13		140	$625
16	$525	151	$625
19	$550	159	$575
27	$525	161	$475
28	$525	162	$475
30	$525	163	$475
36	$560	165	$450
38	$550	166	$400
39	$543	167	$400
40	$540	168	$400
41	$525	169	$400
42	$695	170	$425
43	$715	171	$450
46	$780	180	$550
47	$835	181	$525
70	$525	184	$600
71	$525	185	$515
77	$500	186	$515
78	$500	188	$515
79	$500	189	$515
80	$500	190	$515
81	$500	192	$515
82	$500	193	$575
83	$500	199	$575
86	$475	200	$575
87	$525	201	$550
88	$550		

TERMS:—$100 first payment, then $10 per month. Five

The average price on this list for lots in Curtis Oaks is about $550. That was about two and a half times the price paid to William Curtis for the raw land. (Courtesy of Curtis Sproul.)

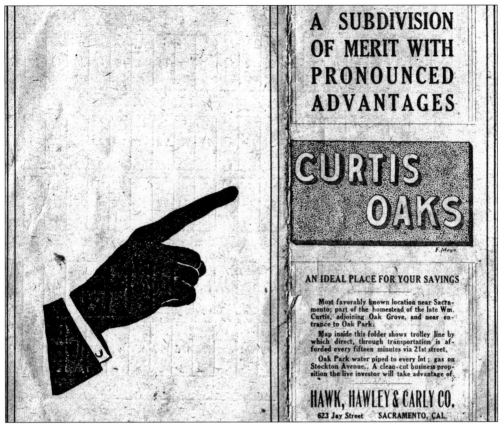

This is a subdivision sales brochure for Curtis Oaks. A prominent sales point is streetcar service every 15 minutes. J. C. Carly reportedly insured this. When rumors began that the streetcar line might go in a different direction, Carly took the matter up with associates at the Sutter Club. They found a suitable candidate to make a successful run for mayor. The streetcar line route was built in 1907 through the middle of Curtis Oaks, down what is now Fifth Avenue. (Courtesy of Brooks Cutter.)

Here is the subdivision map for Curtis Oaks, showing the original street names. The interior north/south streets do not continue through the northern tier of lots. When the land to the north was subdivided, the present continuation of these streets was effected. (Courtesy of Brooks Cutter.)

MODERN AND ARTISTIC HOMES
ESTIMATES FURNISHED

PHONE CAP. 544-J

R. H. RUITER

CONTRACTOR AND BUILDER

2715 SECOND AVENUE (OVER) **SACRAMENTO, CAL.**

Richard H. Ruiter built a number of homes in Curtis Oaks and other early Curtis Park subdivisions. The custom of selling lots piecemeal, with the purchaser arranging for construction, resulted in a diverse streetscape in these subdivisions. (Courtesy of Ivey Lambert.)

Here is the house on Second Avenue, now Fifth Avenue, built by Ruiter for his own family. His daughter Ivey Ruiter (Lambert) was born there. Note the electric power line on the street. It now runs in the alley behind the houses. (Courtesy of Ivey Lambert.)

This is a studio photograph of the Ruiter family. After moving to Portola Way, the Ruiters moved again to Thirty-fourth Street in Oak Park, but returned to Curtis Oaks in 1933. They moved into a house on Fifth Avenue that Ruiter had built for Merit C. Pike. Except for a few years in the late 1940s, Ivey has lived there ever since. (Courtesy of Ivey Lambert.)

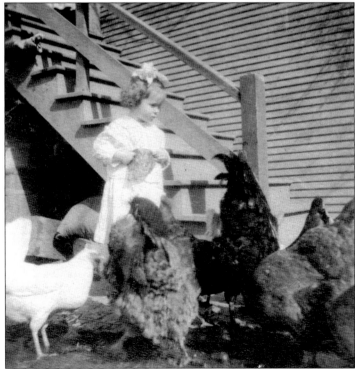

Seen here with the family chickens is Ivey, wearing her characteristic hair ribbon. (Courtesy of Ivey Lambert.)

This is Edna Curtis's wedding in 1908. In 1906, Edna graduated from UC Berkeley. She married John Cooper, a Berkeley classmate. Cooper was to become state superintendent of public instruction, allowing Edna to move back to Curtis Park for a couple of years in the late 1920s. That ended when Cooper was named United States commissioner of education under Herbert Hoover. (Courtesy of Brooks Cutter.)

Here is Carrie Cutter's touring car at Curtis Ranch. A neighborhood news squib in the *Sacramento Bee* in July 1911, reported that Carrie and her family and friends had returned from an automobile trip to Lake Tahoe. "The party will soon leave for another trip to the Bay cities in their big touring car." (Courtesy of Brooks Cutter.)

This is a 1910 vacation picture of J. C. and May Carly. (Courtesy of Curtis Sproul.)

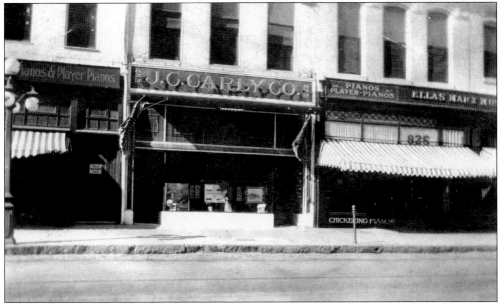

This is a picture of the J. C. Carly Company office at 923 J Street. In 1910, Carly bought out Hawk. (Courtesy of Curtis Sproul.)

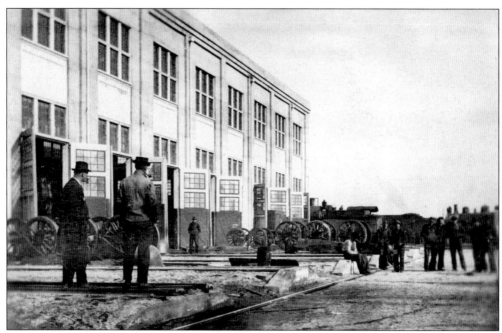

This is a 1910 picture of the Curtis Park railyard shops. They were named the Jeffery Shops, in honor of Western Pacific's early president. (Courtesy of the California State Railroad Museum.)

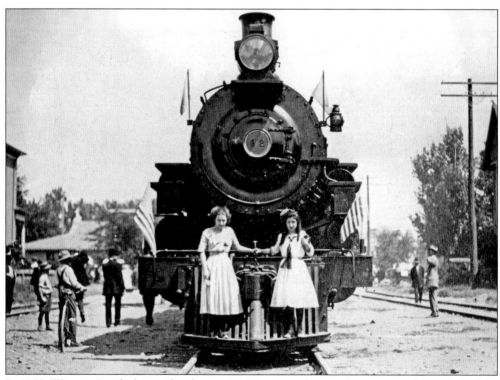

In 1909, Western Pacific began freight service. However, the grand event was the arrival of the first passenger train on July 28, 1910, shown here. (Courtesy of SAMCC.)

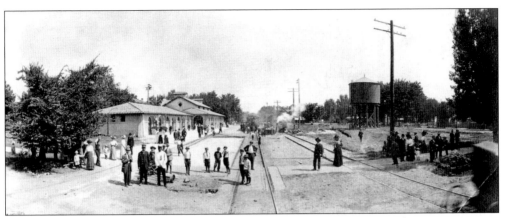

This is a picture of the crowd awaiting the arrival of the first Western Pacific passenger train. The passenger depot for the Western Pacific is now the Spaghetti Factory on Nineteenth and J Streets. (Courtesy of SAMCC.)

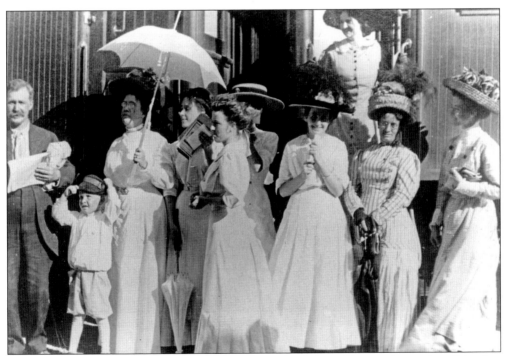

This photograph of disembarking passengers shows the fashionable traveling attire of the day. (Courtesy of SAMCC.)

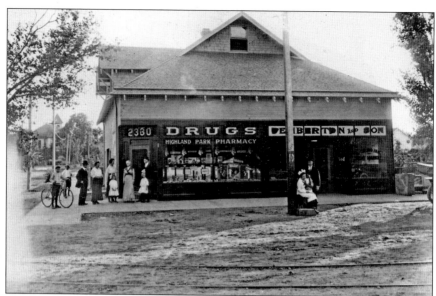

This is a 1913 picture of the Highland Park drugstore at the southwest corner of Twenty-fourth Street and Second Avenue. The Highland Park School is visible in the background. In the foreground are streetcar tracks on the dirt road. The business eventually became Pierson's Drugs, a neighborhood landmark until it burned down. (Courtesy of Bob Blymer.)

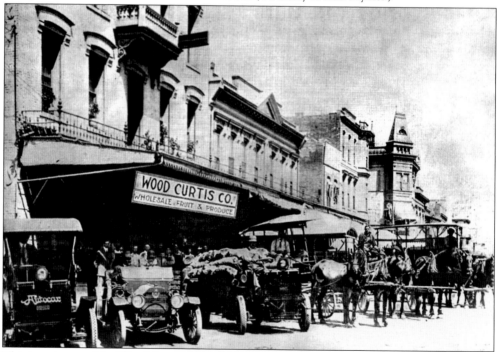

This is a picture of the Wood Curtis Company, c. 1913. Note the mixture of trucks and wagons in use at this transitional time. William Albert Curtis, a founder of the company, was the nephew of William Curtis. He came to the Curtis Ranch from Massachusetts in 1870 at the age of 14. After working there three years, he moved to town and became a successful businessman. (Courtesy of SAMCC.)

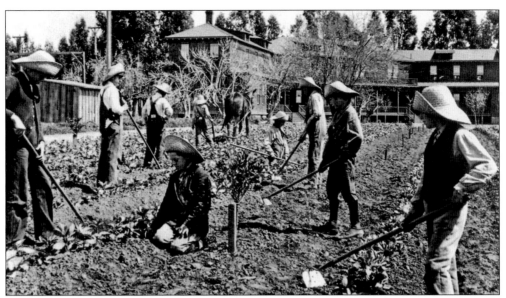

This c. 1910 photograph shows boys farming at the Protestant Orphanage. The activity was to teach them a trade, and was expected to turn a profit. (Courtesy of the Sacramento Children's Home.)

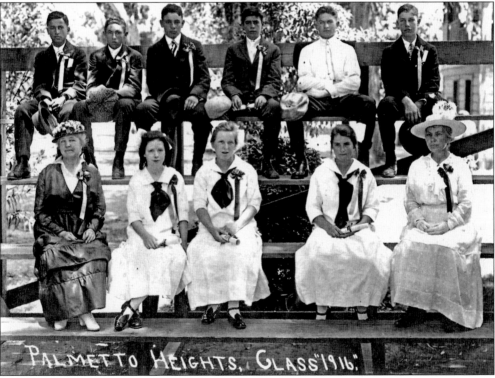

This is the graduating class of 1916 at Palmetto Heights School. Sutterville Road and the extension east of Franklin Boulevard were at one time called Palmetto Avenue. The school was on the orphanage grounds. A dispute arose after annexation over whether Sacramento had acquired it as part of the incorporation of the Palmetto Heights School District. (Courtesy of the Sacramento Children's Home.)

With his carpenter's tools arrayed on his bicycle, Frank P. Williams came to Sacramento around 1909 at the age of 21. He built many homes in Curtis Park over the ensuing decades. (Courtesy of the Frank P. Williams family.)

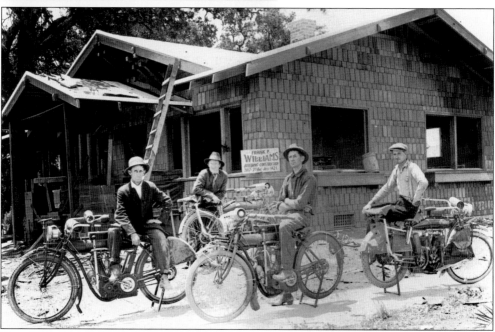

Here Williams and some of his carpenters, at a work site in West Curtis Oaks Addition, pose with the motorcycles he bought them. Unfortunately today Williams is commonly known by a nickname deriding the high pitch of his voice. He loathed it. He threw a fellow who addressed him with it through a plate glass window. (Courtesy of the Frank P. Williams family.)

Curtis H. Cutter seems quite delighted to have reached driving age. Cutter and Frank Williams were friends in later years. They were in Clarence Breuner's office at Fifth and K Streets one day when a dispute arose over who could run faster. They settled it with a 100-yard dash down the middle of the street while Clarence and Wilbur Brand stopped traffic. (Courtesy of Brooks Cutter.)

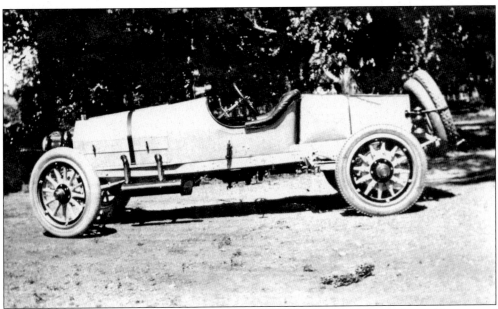

Anyone would be delighted to cruise around Curtis Park in this handsome Stutz. (Courtesy of Brooks Cutter.)

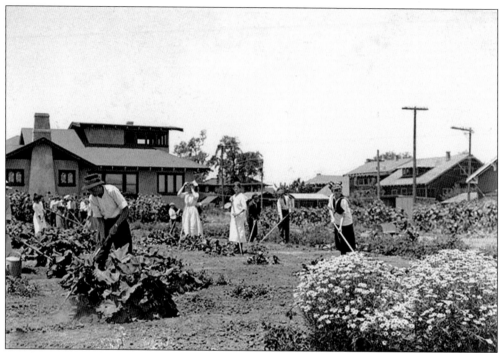

Residents of the orphanage were not the only students of agriculture in Curtis Park before World War I. Here the students of Highland Park School tend the school garden in 1915–1916. (Courtesy of the California History Room, California State Library, Sacramento, California.)

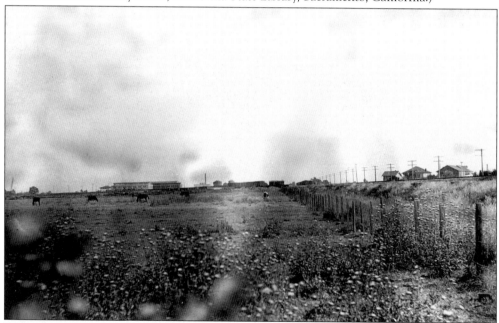

The vantage point in this 1917 photograph of the railyard is the Oak Park Water Company pump house, at the point the alley south of Portola Way bends north at the railroad tracks. A few houses in the Hillcrest Park subdivision are visible to the right on the horizon. (Courtesy of SAMCC.)

In 1917, this was the view south from Donner Way and Twenty-fourth Street. The railroad shops are in the distance. (Courtesy of SAMCC.)

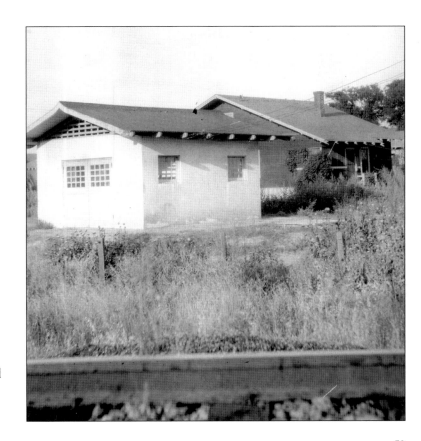

This is the Oak Park Water Company pump house mentioned on the previous page. (Courtesy of SAMCC.)

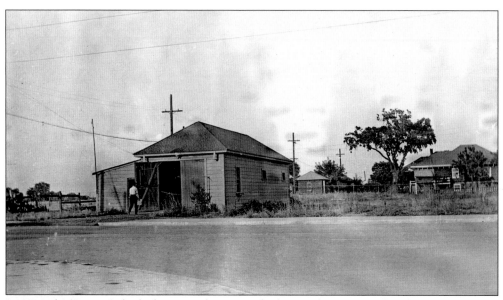

In 1914, the Curtis Oaks firehouse, or hose cart shed, moved to Twenty-fourth Street. There is now a vacant lot where it stood, north of Portola Way and Twenty-fourth Street. One of the arguments in favor of annexation was that the city would provide a fire-pumping engine for the area. Initially volunteer firefighters practiced on Sundays. (Courtesy of SAMCC.)

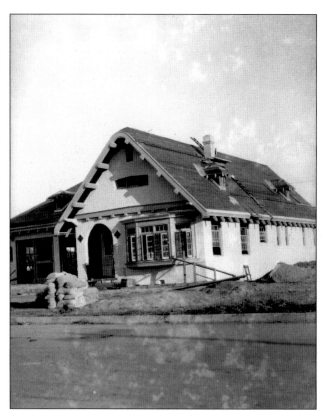

Fire protection remained an issue for early residents. Finally, in 1917, the city constructed a firehouse for professional firefighters at Portola Way and Twenty-sixth Street. In this photograph, construction is almost complete. (Courtesy of SAMCC.)

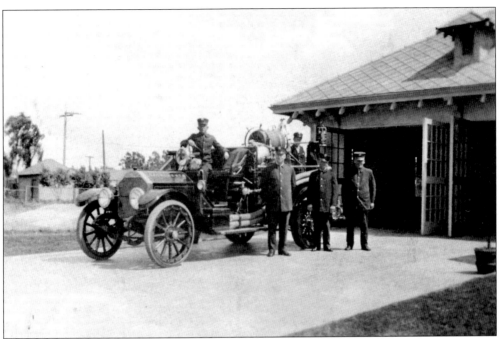

Here are the firemen of the newly opened Portola Way firehouse. At the time, there was only one platoon of firemen per firehouse, 24 hours a day, with only four days off a month. The Curtis Park firemen kept a pet goat. One January day the goat was "kidnapped" from a lot near the station. Fortunately Patrolman Lohmeyer happened by and recognized the goat. He arrested the thief. (Courtesy of Randall Wootton.)

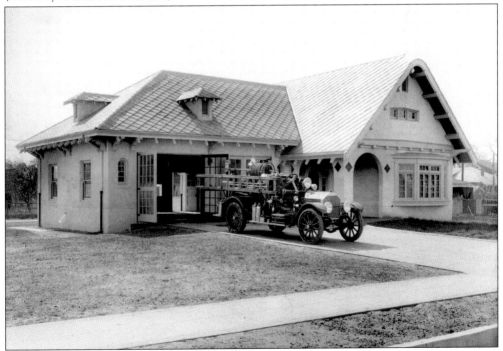

This is the handsome new fire station and its fire engine. (Courtesy of Randall Wootton.)

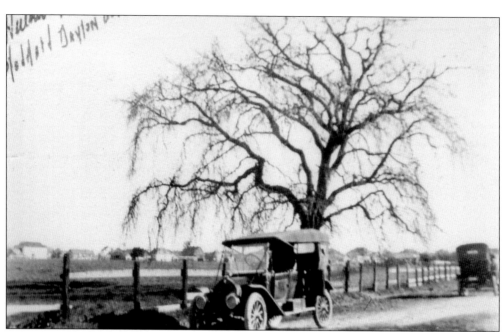

This is the Heilbron tract in 1914. The automobile in the foreground is a Stoddard Dayton. (Courtesy of Hermi Cassady.)

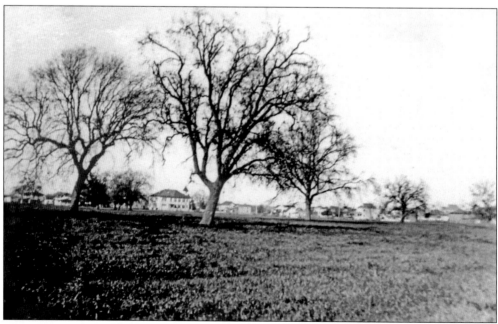

This picture of the Heilbron tract was likely taken on the same motoring expedition. The big building in the background between the oaks is the Highland Park School. (Courtesy of Hermi Cassady.)

Four

THE EARLY AUTOMOBILE SUBURBS OF THE ROARING TWENTIES

Soon after the armistice, preparation for development of the rest of Curtis Park began. Former mayor William Land bequeathed property to be purchased to create a city park. In 1918, there was an unsuccessful bid to have Carrie Cutter's portion of the Curtis Ranch lands purchased for this park. In July 1919, the J. C. Carly Company and Hickman-Coleman Company made a joint proposal to the city to donate a tract for a park down the middle of the Curtis Park lands. After extensive negotiations, the city accepted the park proposal and the land was deeded on November 29, 1919.

On Friday, October 16, 1919, 12,000 school children paraded in support of the proposed school bond issue. The 355 "kiddies" (decked out in orange and white) and more than a dozen teachers of Highland Park School were among them. The proposed bonds were to replace the Highland Park School and build a new elementary school for Oak Grove and southern Curtis Park. The bond issue passed at the election the next day by a margin of seven to one.

On December 22, 1919, Carrie and George Cutter agreed to transfer the east side Curtis Ranch land to the East Curtis Oaks Company, controlled by Carly, for subdivision and sale. Curtis H. Cutter appended the following note: "My mother and father thought they would give Mr. Carly and me a chance to get me started in the real estate business by this agreement."

Carly and the Hickman-Coleman Company coordinated the subdivision of Curtis Ranch. All of it was sold as South Curtis Oaks. On each side of the park there were three subdivisions. On the east side were South Curtis Oaks subdivisions Nos. 1, 2, and 3. The west side were Nos. 4, 5, and 6. The subdivision maps were filed every year or two from 1920 (No. 1) to 1928 (No. 6). On the east side of the park, many of the homes were built by the J. C. Carly Company using materials from the Cutter Mill and Lumber Company, of which Curtis H. Cutter was president.

These, and the other Curtis Park subdivisions of the 1920s, are automobile oriented. The alleys are gone. Driveways to rear garages are common. The house entrance is often oriented to both the street and the driveway. The full porches are gone. Social interaction with a passing motorist is unlikely.

In May 1921, the city board of education approved preliminary plans for two new Curtis Park elementary schools, Bret Harte and Highland Park School. On May 18, 1921, the board authorized an agreement with the Heilbron heirs for 6.23 acres for the new Highland Park School at Twenty-fourth Street and Fourth Avenue for approximately $5,500 per acre. On April 11, 1921, the board, after several weeks of controversy over location for the Bret Harte School, accepted the proposal

of J. C. Carly to sell the east five acres of South Curtis Oaks, subdivision No. 2, for $27,500. The schools were constructed during 1922 and 1923.

The Heilbron Oaks subdivision was not far behind. In 1923, the map was filed. That was also the year that the Y Street (Broadway) levee was removed.

In August 1924, the city board of education voted to purchase the 60.49-acre Gay estate tract on the northeast corner of Sutterville Road and Freeport Boulevard as the new home of the junior college. On October 26, 1926, the dedication ceremony for the new college was held.

In April 1926, the subdivision map for St. Francis Oaks was filed. This subdivision, north of West Curtis Oaks, was developed by Frank P. Williams.

In March 1928, the College Plaza subdivision map was filed. The southernmost portion of this subdivision, just north of the junior college, was marketed as Spanish Town.

Many of the Curtis Park houses of the 1920s were done in a revival style: Spanish, English, Norman, Italian, Greek, or Colonial. The Better Homes Movement, a program sponsored by the federal government, set the tone. Every year, from 1922 through 1929, Sacramento participated in the national Better Homes Week contest. Homes were selected by a local committee each year to represent the city. They were furnished by one of the local home decorating stores, such as Bruener's, and put on display during Better Homes Week for thousands of people to tour. Curtis Park subdivisions shown below were the leaders, providing several contest homes every year.

The lack of additional undeveloped land in Curtis Park and the Great Depression brought this period of suburban development to a close.

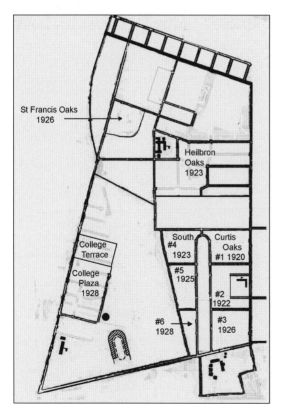

These subdivisions were developed during the 1920s, with the date of filing shown on the subdivision map. (Courtesy of SAMCC.)

This is a young Leita Carly. (Courtesy of Brooks Cutter.)

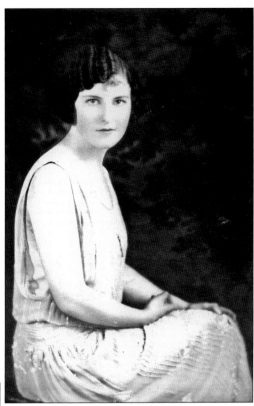

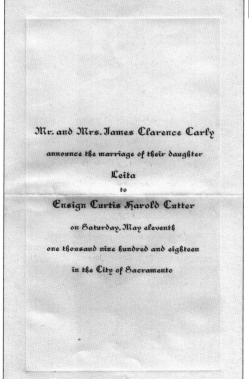

Mr. and Mrs. James Clarence Carly

announce the marriage of their daughter

Leita

to

Ensign Curtis Harold Cutter

on Saturday, May eleventh

one thousand nine hundred and eighteen

in the City of Sacramento

This is the wedding announcement for Leita and Curtis H. Cutter. Cutter served in the Navy on the *Arizona* during the Great War. He returned home on leave for the wedding. (Courtesy of Brooks Cutter.)

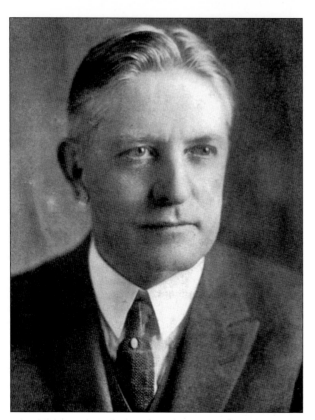

This is J. C. Carly during the 1920s. In 1911, Carly agreed with the Cutters to develop their portion of Curtis Ranch. However, nothing came of this other than efforts to interest the city in buying the property for a park. (Courtesy of Curtis Sproul.)

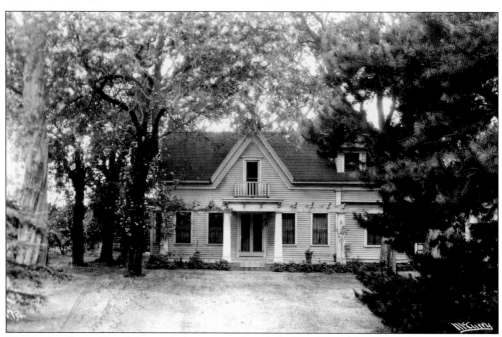

This is the Curtis Ranch house before it was demolished in 1922. (Courtesy of Curtis Sproul.)

Here is May Glen Carly in a studio portrait. Before moving to Curtis Park in the 1920s, the Carlys lived in the city at 1700 G Street. Their first house in Curtis Park was a small one on Donner Way. (Courtesy of Curtis Carly Cutter.)

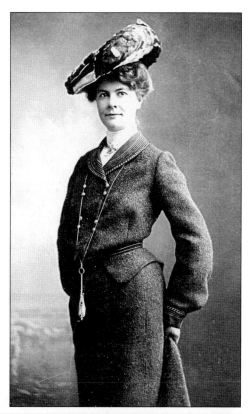

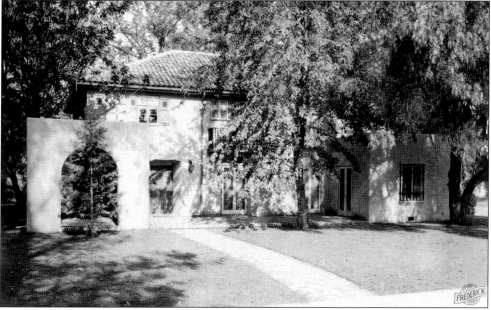

Here is the house the Carlys built in 1922 on Montgomery Way. It was designated a Sacramento historic landmark in the spring of 2005 not only because of the connection to J. C. Carly, but also because of the architectural merit—an example of work by locally prominent architects Charles Dean and James Dean. (Courtesy of Curtis Sproul.)

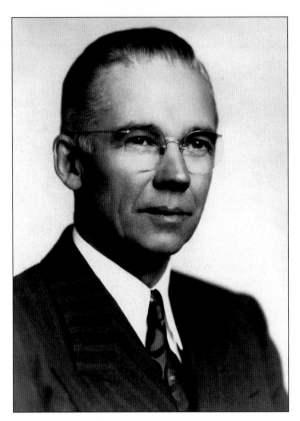

In February 1919, after discharge from the Navy, Curtis H. Cutter, seen here in this 1920s photograph, joined the J. C. Carly Company. (Courtesy of Curtis Sproul.)

CAP. 843-J

ESTIMATES

MANUFACTURERS
SASH, DOORS

SCREENS, MOULDINGS
CABINET WORK

CUTTER MILL & SUPPLY CO.

PLANING MILL

CURTIS H. CUTTER
MANAGER

1755 STOCKTON BLVD.
SACRAMENTO, CALIF.

This is a Cutter Mill business card. Carly and Cutter formed the enterprise to supply lumber and building materials. (Courtesy of Brooks Cutter.)

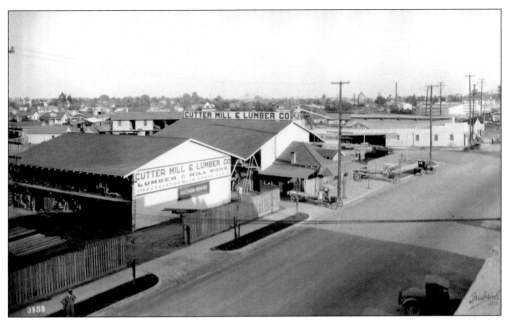

This is the Cutter Mill lumberyard in Oak Park. During the 1920s, Cutter Mill ads were a fixture of the newspaper real estate pages. (Courtesy of SAMCC.)

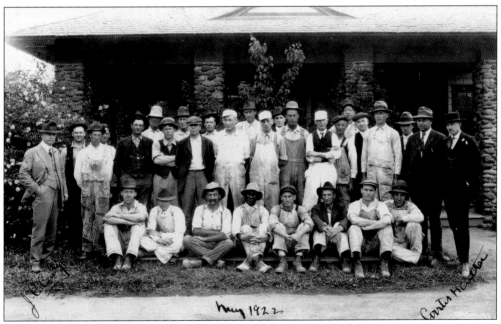

The 1922 J. C. Carly Company home building workforce is pictured above. Carly Company built many of the houses in South Curtis Oaks and other Carly subdivisions, such as Casita in East Sacramento and Homeland in Land Park. (Courtesy of Curtis Sproul.)

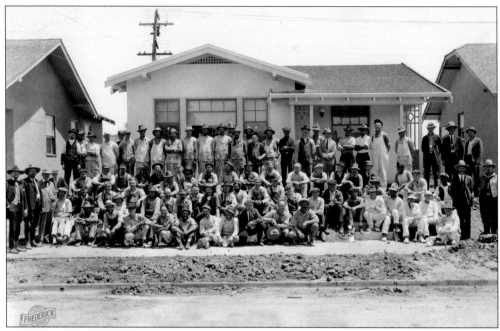

This is the 1923 J. C. Carly Company home building workforce. The increased size provides an indirect measure of the pace of the build out in South Curtis Oaks. (Courtesy of Curtis Sproul.)

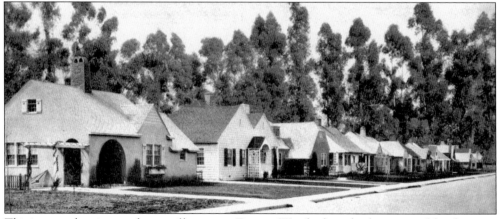

This is a popular picture of a row of houses on Donner Way, built in the first stage of development of South Curtis Oaks subdivision No. 1. The trees in the background are a remnant windbreak for the Curtis Ranch house.

This is George Cutter, president of the California Fruit Exchange. Cutter was active in civic affairs, such as district governor of the Boy Scouts and a founder of Camp Sacramento. He died at home in 1925 at the age of 62. (Courtesy of Brooks Cutter.)

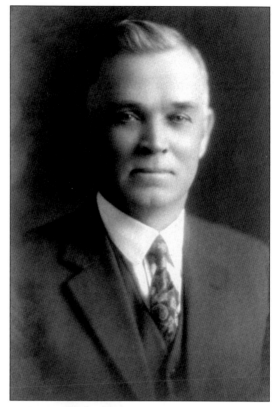

In the early 1920s, Frank Williams built a bridge into Camp Sacramento.

This is one of the Donner Way houses in 1923. At the beginning of the South Curtis Oaks development, Carly engaged the newly formed architectural firm of Dean and Dean to develop designs. Many of the houses in South Curtis Oaks subdivision No. 1, including the row of smaller homes on Donner Way and the more monumental homes of the Carlys and Cutters, were designed by Dean and Dean.

This is a Colonial Revival–style house on Curtis Way in 1923. Like many of the early Dean and Dean–designed houses, it is replicated, with variations, on many blocks throughout the South Curtis Oaks subdivisions. Carly's deed restrictions reserved architectural control. One way to satisfy that constraint was to follow one of these archetypes.

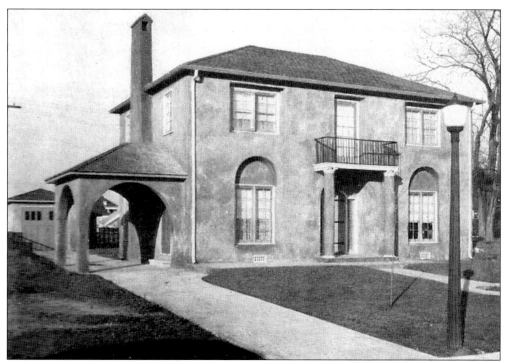

This Italianate house on Montgomery Way was also a Dean and Dean design. It too has offspring throughout the Carly subdivisions.

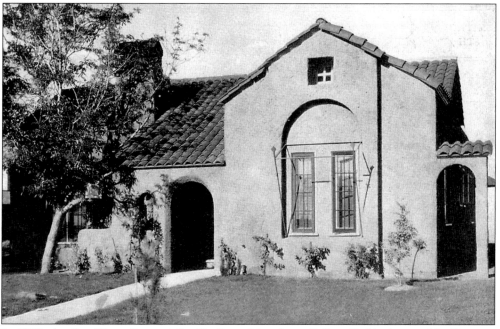

In 1915, the San Diego Panama Pacific Exposition (now Balboa Park), designed by Bertram Goodhue, made Spanish Revival–style architecture familiar and popular throughout the state. This is a 1923 Dean and Dean design in the Spanish/Mediterranean Revival style. South Curtis Oaks has perhaps the greatest concentration of this style house in Sacramento.

This is a 1922 view west from Franklin Boulevard down Montgomery Way. The street, being prepared for sidewalks, curbs, and gutters, bends around the Curtis Ranch oak. (Courtesy of Curtis Sproul.)

In 1922, this was the southwest corner of Franklin Boulevard and Montgomery Way. Carly viewed this intersection as the entrance to his "distinctive home district." E. A. Corum, building superintendent for the J. C. Carly Company, said in the *Union*'s October 28, 1923, issue that he strove to make the houses "contrasting enough in design and type to make each house stand out prominently." (Courtesy of Curtis Sproul.)

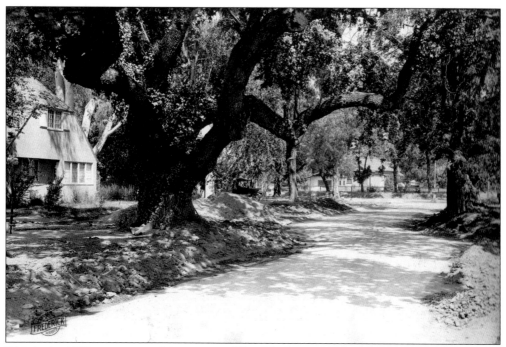

This is the 1922 view east on Montgomery Way. The house on the left was the home of Curtis and Leita Cutter. (Courtesy of Curtis Sproul.)

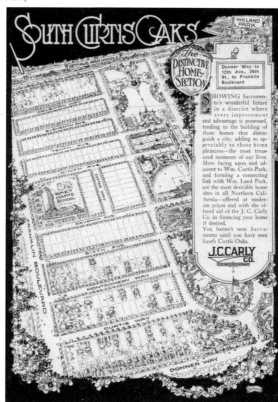

This subdivision map advertises houses built in South Curtis Oaks subdivision No. 1. It also depicts a romantic vision of the future development of William Curtis Park.

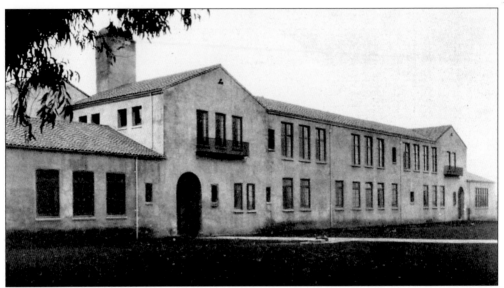

This is the newly built Bret Harte Elementary School, *c.* 1923. Bret Harte and Sierra School were designed by a consortium of local architects who joined forces for the project. The design can also be attributed to Dean and Dean. James Dean was the chief deputy of the consortium and initialed the final plans.

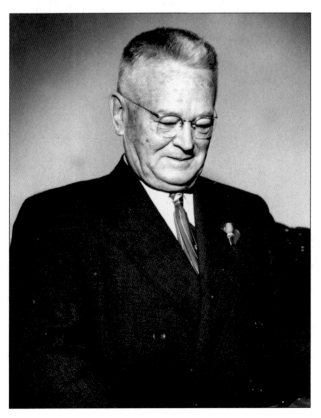

This is a picture of James Dean. He left the Dean and Dean firm in 1929 to become the Sacramento city manager. In 1943, he became the deputy state director of finance, and later director. He supervised the planning of the postwar state building program, including the Curtis Park Department of Motor Vehicles complex. When he died in 1962, he was living in a modest cottage on Twenty-fourth Street between Fourth Avenue and Marshall Way. (Courtesy of SAMCC.)

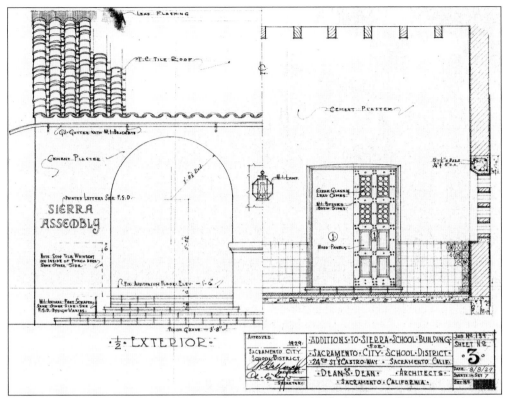

Dean and Dean were the sole architects of the 1923 Sierra School addition and the 1929 auditorium plans. Sierra School, now the Sierra 2 Center, was designated a Sacramento historic landmark in June 2005. It is an excellent example of its property type, a neighborhood elementary school; of its architectural style, Spanish, specifically Andalusian/ Vernacular revival; and the work of an important architectural team. (Courtesy of SAMCC.)

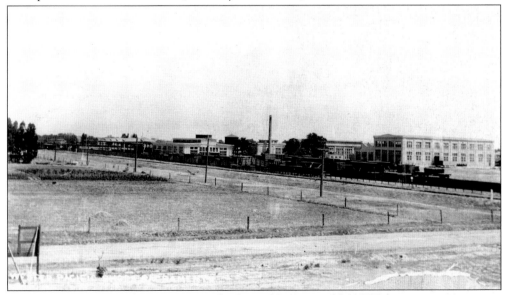

This is a 1920s view of the Western Pacific shops. (Courtesy of SAMCC.)

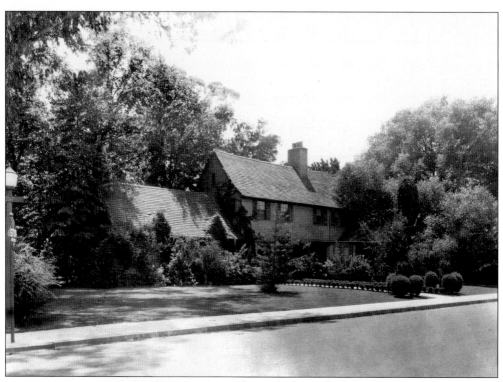

This is the house built by Carrie and George Cutter on Curtis Way. After George Cutter died, Leita and Curtis Cutter moved from their house next to the Carly's on Montgomery Way, and shared this house with Carrie until she died.

This is young Caramay Cutter about 1925 at the Cutter house on Curtis Way. Her given name blends those of her grandmothers. She is a fourth generation member of the Curtis clan to have lived at the Curtis Ranch site. (Courtesy of Brooks Cutter.)

During the boom years of the 1920s, undeveloped lots in earlier Curtis Park subdivisions were also built on. This is a 1925 view north from Sixth Avenue in Hillcrest Park off Freeport Boulevard. Herb Pettengell and Herb Jr. are in front of their Sears kit home, which Herb Jr. recounts was put up with two adjacent homes by builder Frank Williams. (Courtesy of Herb Pettengill Jr.)

Here the Pettengells are joined by the Browse family. Herb Jr. recalls watching soccer games at a field in the northern part of the railyard between the Western Pacific shops team and other teams sponsored by local businesses. The field was also used on occasion by circus shows traveling the Western Pacific route. (Courtesy of Herb Pettengill Jr.)

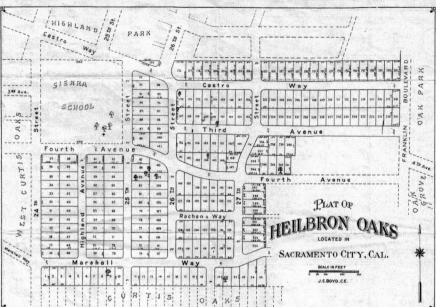

In 1923, development for Heilbron Oaks began. Here is the subdivision map from an advertising brochure. Like the South Curtis Oaks subdivisions, Heilbron Oaks deeds contained a racial ownership restriction. "[N]o Negro, Japanese or Chinese, or any person of African or Mongolian descent shall own or occupy any part of said premises."

This is the Roberts family home under construction on Twenty-fifth Street. The building in the background is Sierra School, no longer visible from this vantage point due to later houses. Mrs. Mary Lou Roberts was a descendant of August and Louise Heilbron. (Courtesy of Nian Roberts.)

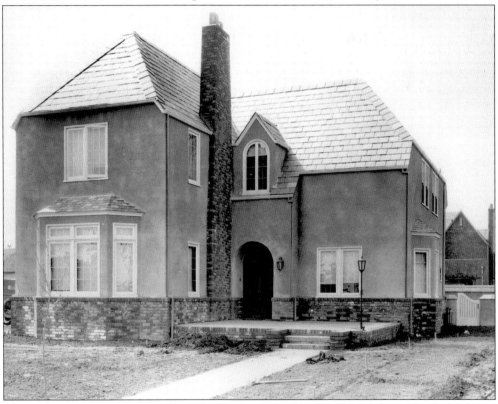

This is the Twenty-sixth Street house built in 1925 for the Harold J. McCurry family. McCurry founded the camera/photograph firm that bears his name. (Courtesy of Harlene Barrett.)

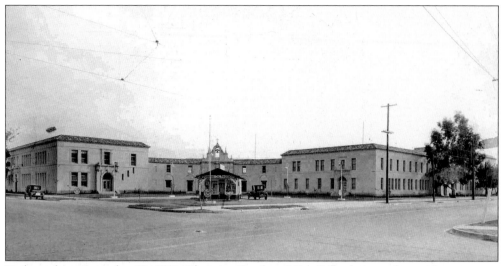

Dedicated on November 23, 1924, Christian Brothers High School sits at the southeast corner of Twenty-first and Y Streets (Broadway). The lumber and moldings were supplied by the Cutter Mill Company. (Courtesy of Brothers of the Christian Schools District Archives.)

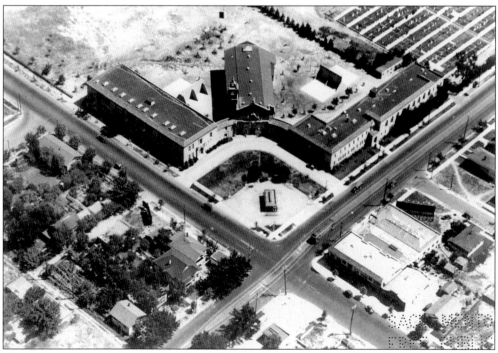

This aerial view of the new high school shows the intersection and a trolley headed south on Twenty-first Street. (Courtesy of Brothers of the Christian Schools District Archives.)

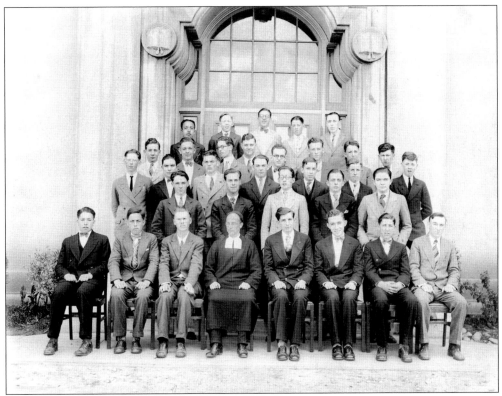

The Christian Brothers graduating class of 1928 was the first class to attend all four years at the new facility. (Courtesy of Jean Baldwin.)

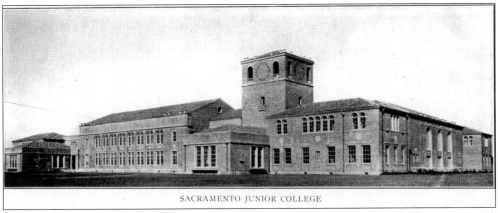

SACRAMENTO JUNIOR COLLEGE

In 1926, the new junior college was completed. It was yet another Dean and Dean–designed, Curtis Park institution. (Courtesy of the Sacramento Room.)

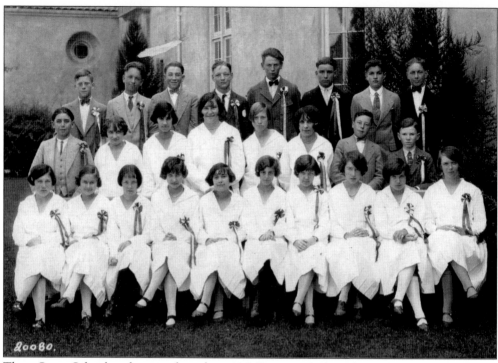

These Sierra School students graduated in 1925. Two years before, the students lined up two by two on the steps of Highland Park School and, led by Principal Alta Rowe, marched across the street to the brand new Sierra School. The gentleman on the right in the middle row is Albert Rodda, future member of the California State Senate. (Courtesy of Margaret Rodda.)

This Charming Picture is of the new

"Golden State" Bungalow

On the Corner of 8th Ave. and 26th Street

(Erected by Architectural Building Co.)

Completely Furnished by Hale Bros., Inc.

One of the Better Homes Week contest winners in 1926, this bungalow surveys William Curtis Park from Eighth Avenue and West Curtis Way. The Better Homes movement was touted as the cure for the ills of modern society. One result aimed at was diminishing the popularity of jazz music.

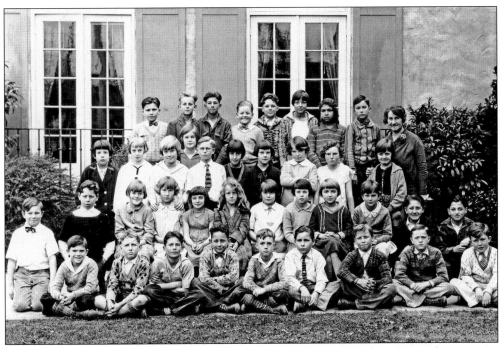

This photograph show 1928 Sierra School graduates. (Courtesy of Harlene Barrett.)

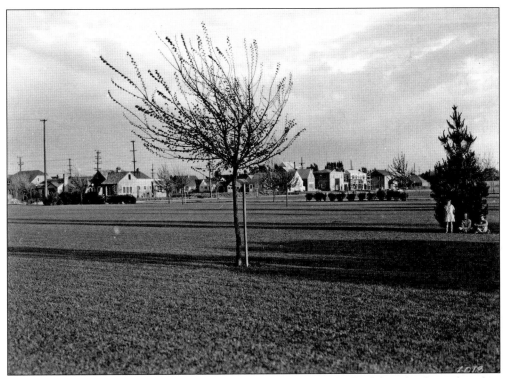

In 1926, new houses and empty lots along East Curtis Way are the backdrop for the park and its newly planted trees. (Courtesy of SAMCC.)

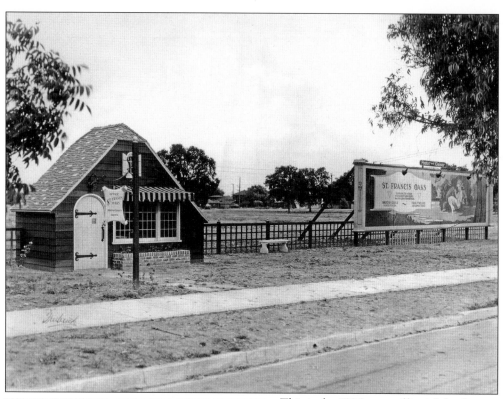

This is the 1926 tract office of the St. Francis Oaks subdivision, "said to be," according to the April 23, 1926, *Union*, "the finest bit of architecture in the city, looking like a regular Hansel and Gretel house without the witch . . . It is built by Frank P. Williams and is the embodiment of one of his ideas." Half of the lots were sold on opening day that May. (Courtesy of the Sacramento Room.)

Frank Williams, seen here in 1926, is best known for his local houses on Markham Way. These include his own home and the home of Charles Dean of Dean and Dean. Dean lived in his home until his death in July 1956. (Courtesy of the Frank P. Williams family.)

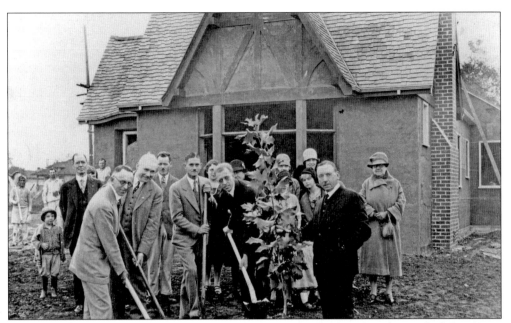

In 1927, Heilbron Oaks shows off some proud new owners. The first shoveler on the left is Harry A. Nauman Jr., of Nauman and Son Funeral Directors. Wearing a white cap and peeking over the top of the young lady's head is the other proud new owner, Elsa Nauman. In the foreground is Harry Nauman Sr. (Courtesy of Jeff Karlsen and Tracy Kenny.)

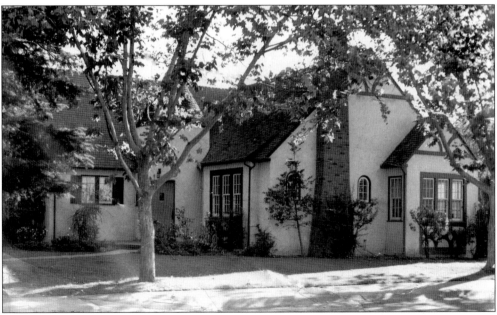

This is another new Heilbron Oaks home on Twenty-fifth Street. Here the oriental plane trees have begun to reach for the sky. The tract brochure promised such shade trees "at no expense to the buyers of lots." McPherson and Luttinger's *History of Sacramento's Urban Forest*, available on the Internet, recounts the history of city support for street tree planting such as providing free trees. (Courtesy of Sheila and David Enos.)

Visit Bret Harte
NORMAN CASTLE

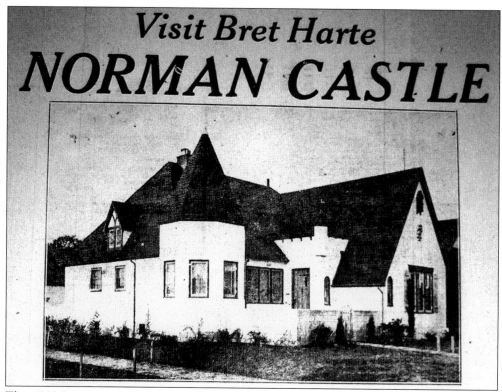

This 1928 Better Homes Week selection was built by N. H. Lund. Lund built many homes in South Curtis Oaks. Schools and school organizations were directly involved in organizing the Better Homes Week activities.

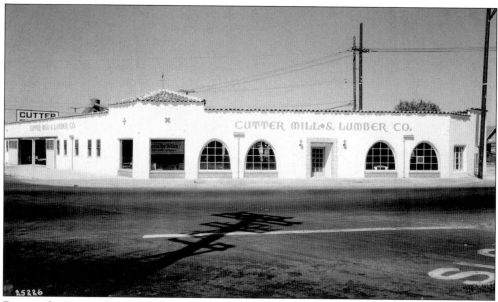

During the 1920s, the Better Homes idea was extended to refurbishing existing housing and businesses. The makeover given to the salesroom of the Cutter Mill facility is shown here. (Courtesy of Curtis Sproul.)

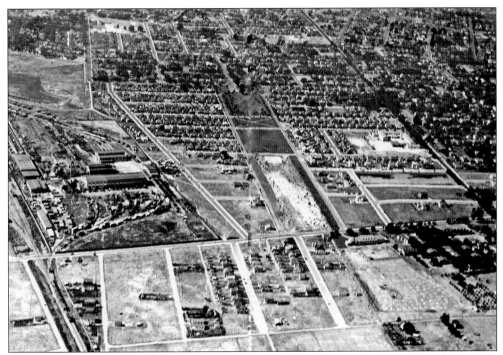

In this late-1920s aerial view, South Curtis Park reveals the progress made from north to south. (Courtesy of Curtis Sproul.)

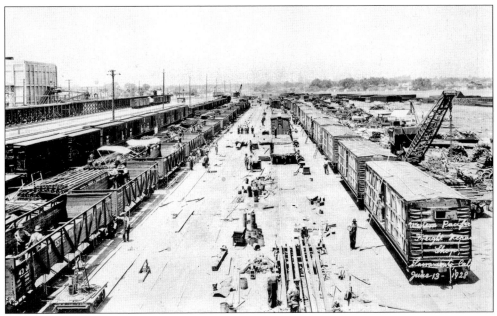

This busy 1928 scene at the Western Pacific shops illustrates the employment opportunities it brought to the area. (Courtesy of the Sacramento State Railroad Museum.)

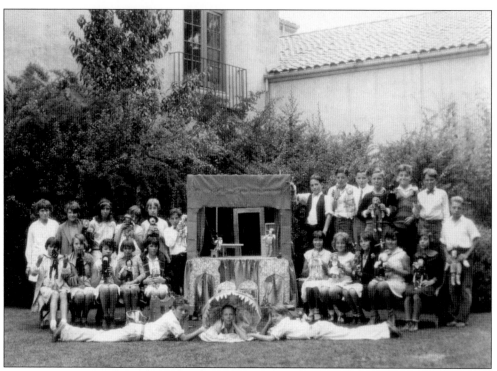

The theme of this Bret Harte puppet show in 1929 is unknown. (Courtesy of the Sacramento Room.)

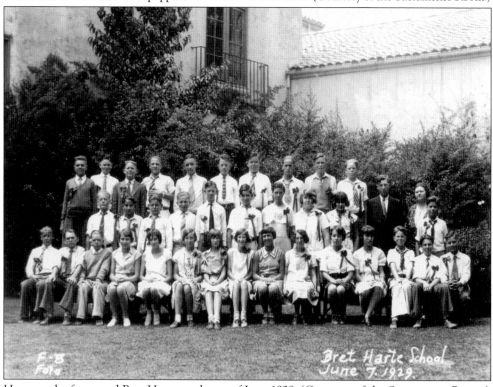

Here are the festooned Bret Harte graduates of June 1929. (Courtesy of the Sacramento Room.)

Five

FROM THE GREAT
DEPRESSION TO THE PRESENT

The Great Depression took hold more slowly in California than elsewhere, but take hold it did. J. C. Carly and Curtis H. Cutter financed, as well as built, many of the houses they sold in the 1920s. When the Depression hit, many houses were turned back over to Carly and Cutter as mortgage holders, resulting in great financial difficulties.

The Sierra School PTA minute book reflects the changing times. The November 20, 1930, minutes state: "After a discussion of Christmas plans, it was moved to dispense with candy for the children this year and use the money for more useful giving." The ensuing years' entries make frequent reference to discussions of federal relief, milk drives, clothing and shoes for donation to the needy, and even an National Recovery Act skit by the fifth grade.

The years of World War II were also years of hardship and scarcity. Commodities, including meat and gasoline, were rationed. The siren at the Western Pacific shops announced nighttime blackouts. Air raid wardens patrolled streets and knocked on doors if they spied any light peeping through blinds and curtains.

Soon after the war, the California state government embarked on a massive building campaign. The development of the Department of Motor Vehicles complex in northern Curtis Park impacted the landscape greatly. The majority of the oldest housing in Highland Park was sacrificed. The Depression and the war years had aged the original streetcar suburbs and old housing was not in fashion.

The high-powered automobile gave access to brand new housing, remote from the original city grid. In the 1960s, the building of the freeway took over. The South Sacramento freeway, now Highway 99, tore a strip through Oak Park and Oak Grove and walled the eastern border. Then the W/X Freeway and the Oak Park interchange did the same to the north.

The 1970s brought the Field Act earthquake safety standards. Bret Harte School was replaced and Sierra School slated for removal. However, the tide of deterioration and demolition began to turn. The neighborhood organized to save Sierra School as a community center, and the Sierra Curtis Neighborhood Association (SCNA) was born. SCNA also conducted a successful campaign against noise and light pollution from freight loading operations, and shop work at the Western Pacific yard diminished.

In 1982, Western Pacific was merged with Union Pacific. With the cessation of activity at the railyard, a proposal to develop the yards for commercial and residential uses was put forth. Because there were repeated reports that pollution problems were more significant than first thought, the proposal languished. In 2003, Union Pacific agreed to sell the land to Paul Petrovich. Petrovich has submitted a mixed commercial and residential development proposal which is being evaluated by the city and Curtis Park residents. Sometime in the near future, the first new residential development in 80 years will probably begin construction.

Because school entry and classes were staggered, each grade level at the Bret Harte School had both A and B classes that graduated students in January or June. Seen here are the January 1930 graduates. (Courtesy of the Sacramento Room.)

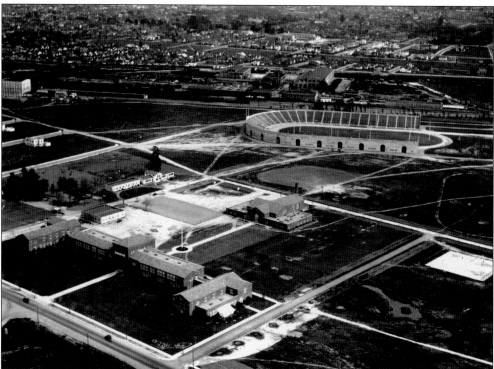

This early view of the junior college shows some of South Curtis Oaks in the background. (Courtesy of SAMCC.)

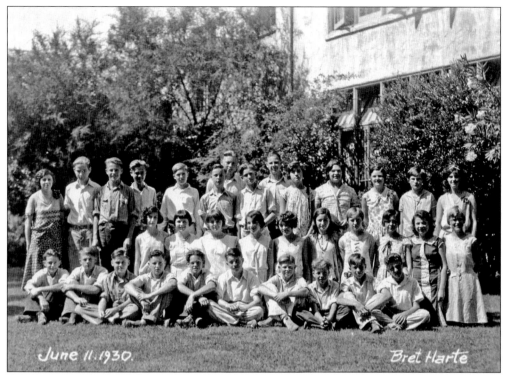

In June 1930, these students are graduating from the Bret Harte School. (Courtesy of the Sacramento Room.)

The Sacramento Children's Home and Orphanage dormitory and administration building was designed by Dean and Dean. This picture was taken in 1930, shortly before changing attitudes ended use of orphanages in favor of the foster care system. (Courtesy of the California History Room, California State Library, Sacramento, California.)

In 1934, Engine Company No. 7 moved from Portola Way to this new facility on Freeport Boulevard, the present site of the Fourth Avenue light rail station. (Courtesy of Randall Wootton.)

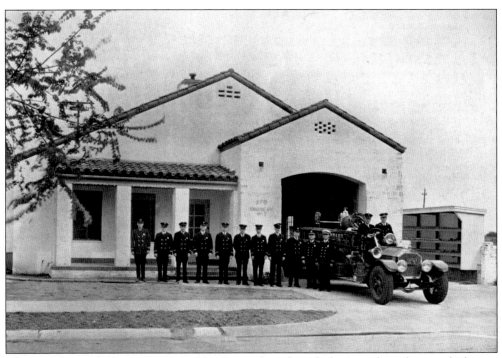

The firefighters of Engine Company No. 7 pose for a formal photograph at the new firehouse. (Courtesy of Randall Wootton.)

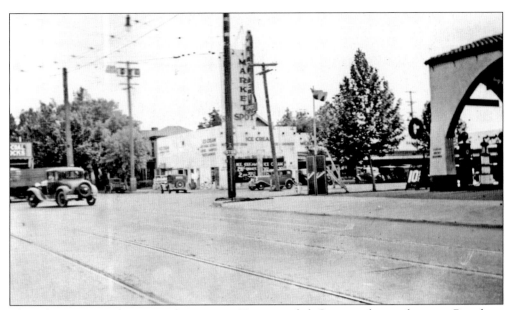

The other Curtis Park streetcar line ran out Twenty-eighth Street and turned east on Broadway toward Oak Park. Here is the intersection at Twenty-eighth and Y Streets in 1934, showing rails and powerlines. (Courtesy of SAMCC.)

This 1935 production was staged at the Bret Harte School. (Courtesy of the Sacramento Room.)

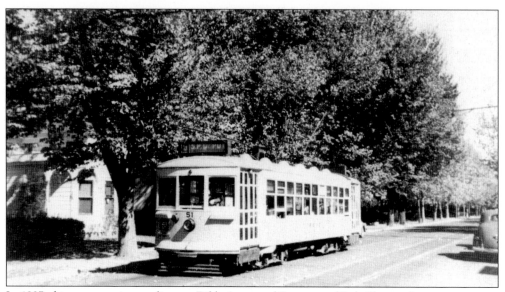

In 1937, this streetcar is traveling on Fifth Avenue. (Courtesy of Bob Blymyer.)

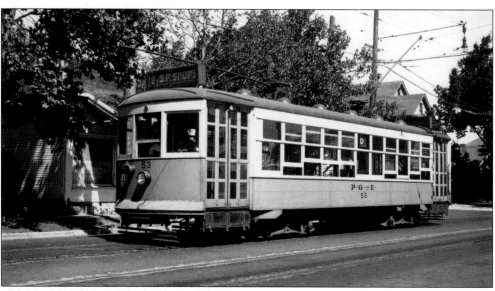

Also in 1937, this streetcar is at Fifth Avenue and Franklin Boulevard. (Courtesy of Bob Blymyer.)

Life was not all grim during the Depression years. Here the boys of Curtis Way and Montgomery Way—Carly (Cutter), Jack, Johnnie, Morley, Nian (Roberts), and Frosty—participate in a fun, recurring event commemorating the 49ers. (Courtesy of Quincy Brown.)

In high style, Morris and Lena Goldstein of Twenty-sixth Street in Heilbron Oaks also participated in the commemoration event. The Goldsteins were one of two Jewish families in Heilbron Oaks. Because he knew someone in the firm handling sales, Morris was able to purchase a lot despite the de facto restriction against Jewish people. (Courtesy of Laurie Goldstein.)

The Bret Harte School graduates of 1937 are shown in the photograph. (Courtesy of the Sacramento Room.)

In 1937, cars could travel both ways across the railroad track at Twenty-first Street and Fourth Avenue. Curtis Park would see such opposing traffic again under the two-way conversion project adopted in 2004 by the city council. (Courtesy of SAMCC.)

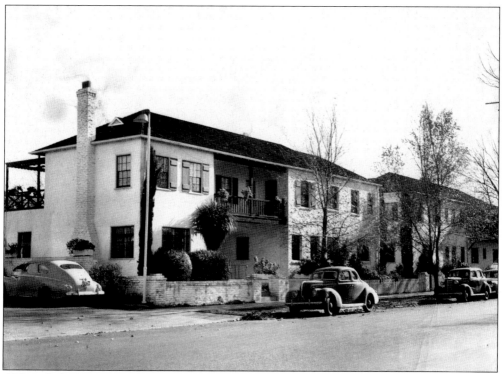

Although the Depression dramatically slowed building, some construction did occur. About 1938, the irrepressible Frank P. Williams built these handsome apartments on Twenty-first Street near Second Avenue. The owner, Doc Visser, was quite a colorful character. After competing in the sport of wrestling, he became a wrestling promoter. (Courtesy of Alice Worlow.)

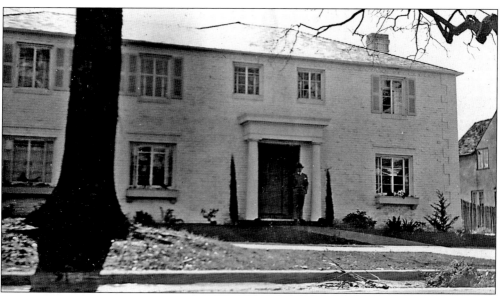

Frank Williams also built this house on Montgomery Way in 1938, for the parents of Quincy Brown. (Courtesy of Quincy Brown.)

In the great windstorm of February 1938, Curtis Oaks received its share of fallen trees. The city lost about six percent of its trees, and 280 houses were damaged. Here is one of the fallen trees on Montgomery Way. (Courtesy of Quincy Brown.)

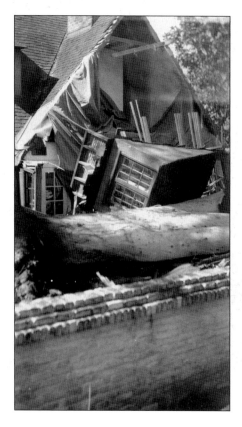

The house that Curtis and Lieta Cutter had built on Montgomery Way was one of the damaged homes. (Courtesy of Quincy Brown.)

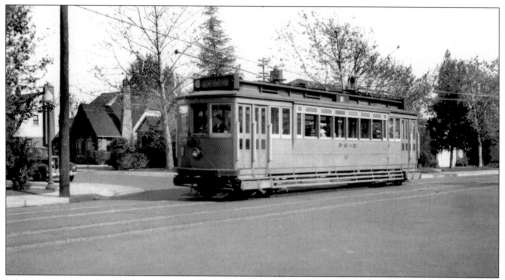

This streetcar is at Twenty-fourth Street and Marshall Way in 1938. (Courtesy of Bob Blymyer.)

This is the grand opening of Gunther's in a little store near Franklin Boulevard and Fifth Avenue in 1940. P. B. Rackliffe developed the business area here on the east side corners in the 1920s to take advantage of the building boom. (Courtesy of Marlena Klopp.)

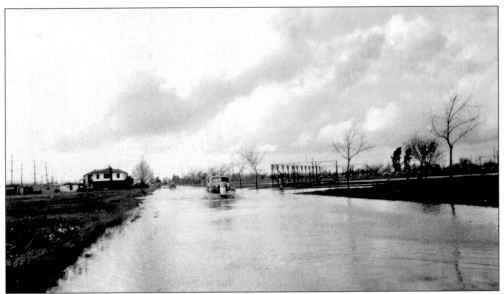

The upgraded levee system did not end all flooding in Curtis Park. This February 1940 storm dumped enough rain to flood Sutterville Road. (Courtesy of SAMCC.)

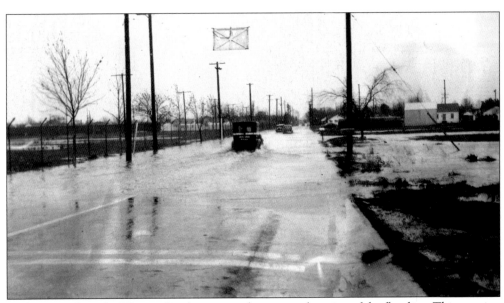

Looking east from the Western Pacific crossing, here is another view of the flooding. This crossing is now bridged by the Sutterville Road overpass. (Courtesy of SAMCC.)

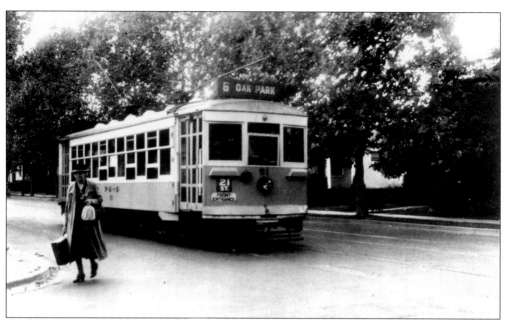

In 1943, this streetcar is headed toward Oak Park from downtown. (Courtesy of Bob Blymyer.)

Here a 1943 streetcar headed downtown is turning on to Twenty-fourth Street from Fifth Avenue. (Courtesy of Bob Blymyer.)

In 1943, the water tower at the city college appears in camouflage dress. For the duration of the war, the water tower kept this paint job. (Courtesy of SAMCC.)

Soldiers are exercising along the railroad tracks at the Freeport Boulevard crossing. Their troop train had stopped in the railyards on Christmas Day 1944. (Courtesy of SAMCC.)

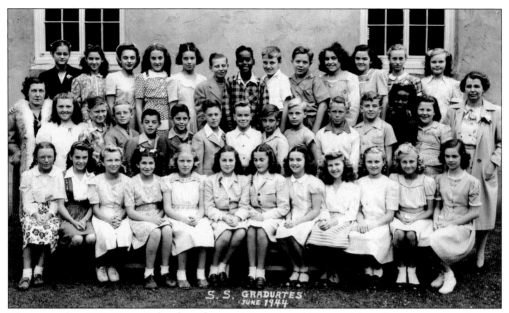

These are the 1944 Sierra School graduates. (Courtesy of Harvey Myers.)

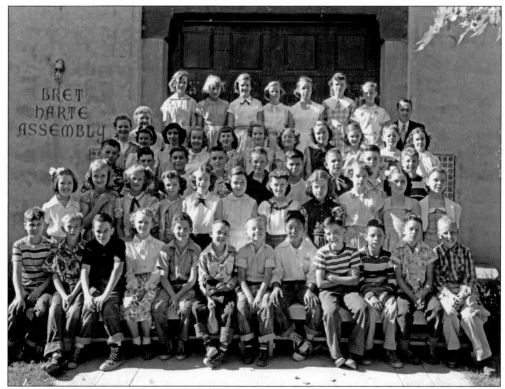

The 1945 Bret Harte School class picture is seen here. (Courtesy of the Sacramento Room.)

In 1949, Gunther's celebrates opening day at its present location at Franklin Boulevard and Third Avenue. (Courtesy of Marlena Klopp.)

This is a leafy view of the Portola Way firehouse after Engine Company No. 7 vacated the property. It was later used by the Boy Scouts. (Courtesy of SAMCC.)

This pergola and restrooms stood near the tennis courts in William Curtis Park. Designed by Charles Dean, they were built around 1938. (Courtesy of SAMCC.)

Although it is now gone, this toolshed was another William Curtis Park improvement. (Courtesy of SAMCC.)

This corner house on Burnett Way and Twenty-fourth Street, pictured here in 1949, is the only survivor of the Highland Park houses north of Sloat Way. (Courtesy of SAMCC.)

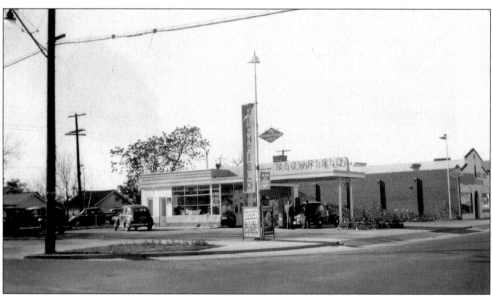

This is the southwest corner of Broadway and Twenty-fourth Street in 1949. The property has been used as a gas station for more than 50 years. (Courtesy of SAMCC.)

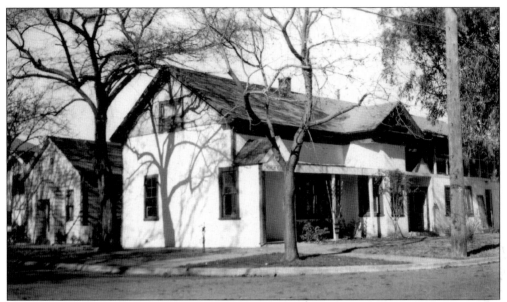

This December 1949 photograph, taken at the former site of the God and Christ Church on the northwest corner of Twenty-fourth Street and Sloat Way, remarks in the caption, "now the residence of a Negro family." This is an early indication of a crack in the Curtis Park housing color line. (Courtesy of SAMCC.)

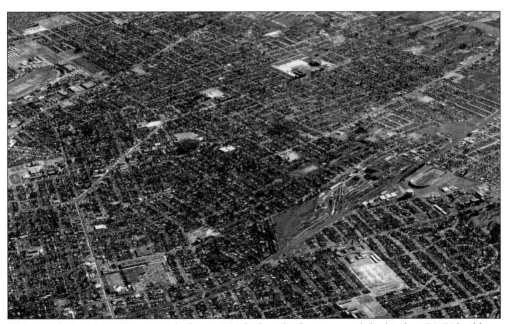

This aerial view shows Curtis Park about 1954, before the freeways and the big-box DMV building. (Courtesy of SAMCC.)

This January 1950 view of West Curtis Oaks is from Freeport Boulevard at about Vallejo Way. (Courtesy of SAMCC.)

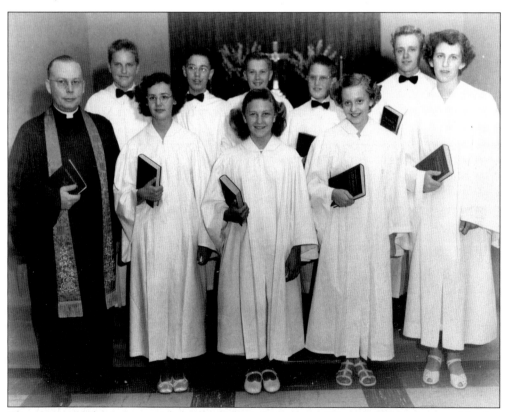

These young Lutherans are confirmed in 1950 at the Lutheran Memorial Church, one of the few large church buildings in Curtis Park, at Twenty-first Street and Larkin Way. Most of the major denominations were housed outside Curtis Park. Residential building restrictions in subdivision deeds were one factor in this exclusion. (Courtesy of Duane Malme.)

This January 1950 view looks north on Twenty-fourth Street at the corner of First Avenue and Twenty-fourth Street. (Courtesy of SAMCC.)

This folk Victorian, with Italianate form and simplified Queen Anne corner tower, stood on the southeast corner of First Avenue and Twenty-fourth Street. Shown here in March 1950, it will soon be gone to make room for the DMV buildings. (Courtesy of SAMCC.)

Here is another January 1950 view, north on Twenty-fourth Street from Sloat Way. The street will soon be closed to begin the construction of the DMV complex. (Courtesy of SAMCC.)

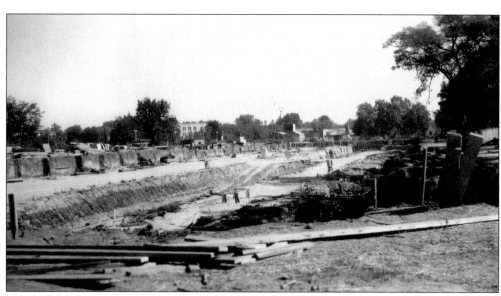

This is the construction site of the first DMV building in August 1951, looking north. (Courtesy of SAMCC.)

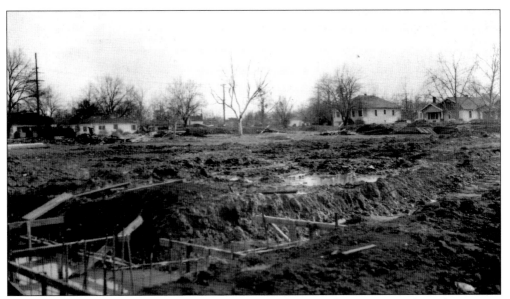

In January 1952, this site was cleared for the east addition to the DMV complex. The vantage point is First Avenue and Twenty-fourth Street. (Courtesy of SAMCC.)

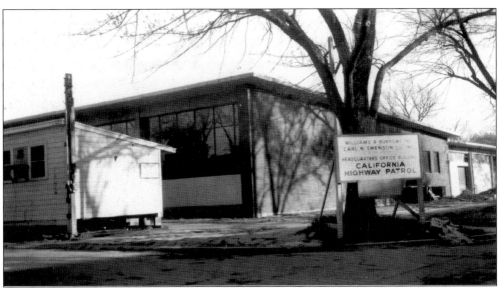

In 1952, the first highway patrol building nears completion. (Courtesy of SAMCC.)

This February 1952 view shows William Curtis Park at Eighth Avenue. (Courtesy of SCNA.)

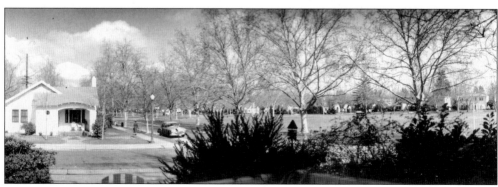

This is another February 1952 view of William Curtis Park. (Courtesy of SCNA.)

This is the new DMV building in June 1952. (Courtesy of SAMCC.)

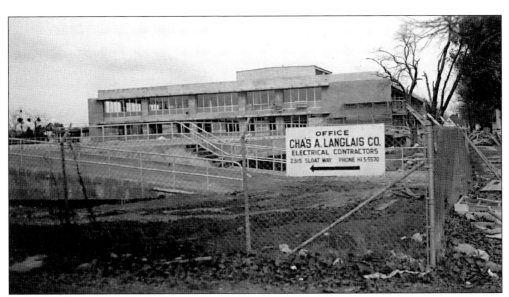

Seven months later, in January of 1953, this is the state of construction. (Courtesy of SAMCC.)

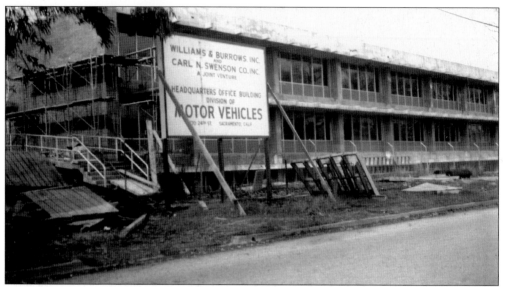

In April 1953, the first DMV building nears completion. (Courtesy of SAMCC.)

In April 1953, this is the view north on Twenty-fourth Street from Sloat Way. The new highway patrol building is on the right. (Courtesy of SAMCC.)

In April 1953, this is the view south on Twenty-fourth Street from Burnett Way. Phase No. 1 of the DMV building program is complete. (Courtesy of SAMCC.)

A similar view to the preceding photograph, a block north at Broadway, four months later, shows the effect of the street widening project. (Courtesy of SAMCC.)

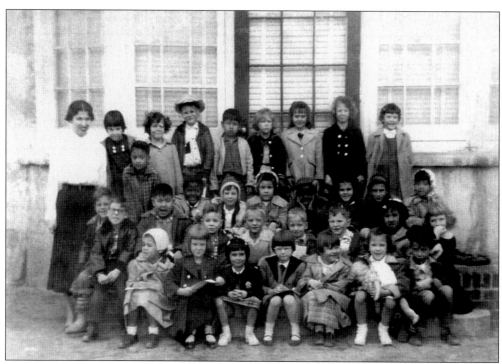

An early 1950s Sierra School kindergarten assembles on the steps outside their room. The kindergarten room, in keeping with its transitional role, has a fireplace and its own entry to a sequestered outdoor play area. (Courtesy of Laurie Goldstein.)

The 1955 Bret Harte School graduates pose here. (Courtesy of the Sacramento Room.)

116

In 1956, the first African American children graduated from the Bret Harte School. The end of World War II marked the beginning of diversity in ethnicity. However, in 1952, when Eva Rutland and her family moved to Twenty-seventh Street, north of Second Avenue, de facto housing segregation strictly barred African Americans from Curtis Park south of the Sutter grant line. (Courtesy of the Sacramento Room.)

The Elks No. 4 team poses at the playing field behind the Sacramento Children's Home, c. 1956. This was the little league home field for Curtis Park. (Courtesy of Don Conner.)

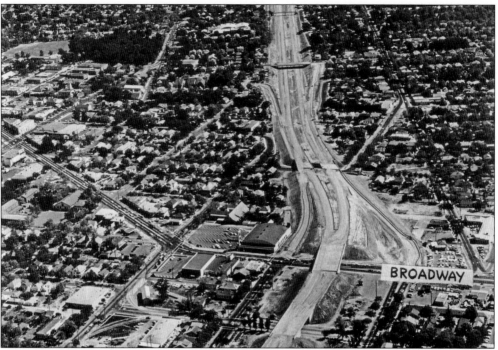

This is the South Sacramento Freeway under construction, *c.* 1957. (Courtesy of SAMCC.)

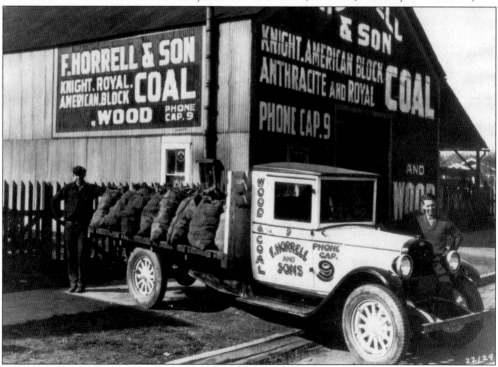

The Horrell family wood and coal yard on First Avenue was one of the many casualties of the South Sacramento Freeway. Three generations of Horrells have lived in Heilbron Oaks. (Courtesy of Sally Aldinger.)

This is the Second Avenue overpass of the new South Sacramento freeway in November 1958. (Courtesy of SAMCC.)

The 1959 graduates of the Bret Harte School are pictured here. (Courtesy of Don Conner.)

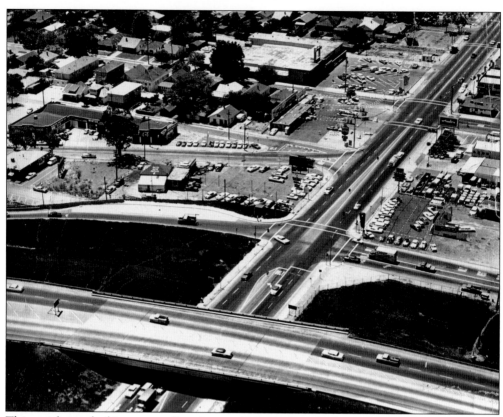

This aerial view, looking west on Broadway in 1960, displays the dominance of automobile related enterprise. (Courtesy of SAMCC.)

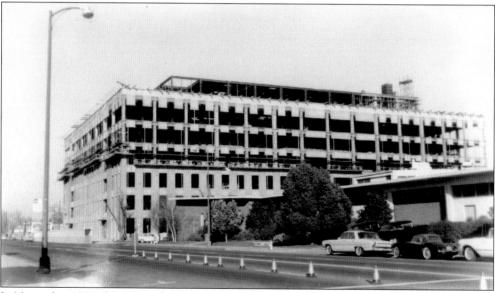

In November 1961, the giant cubical DMV building on the east side of Twenty-fourth Street was nearing completion. (Courtesy of SAMCC.)

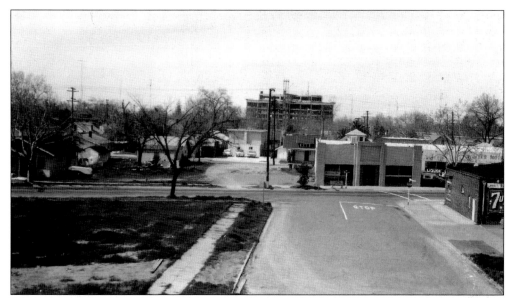

This March 1962 view of the rising DMV building is from the new south area freeway at First Avenue. The building in the right foreground is Leejo's (now Cheers) tavern. It was opened by Lee Horrell and Joe Marty in March 1933 and run by Horrell for 47 years. (Courtesy of SAMCC.)

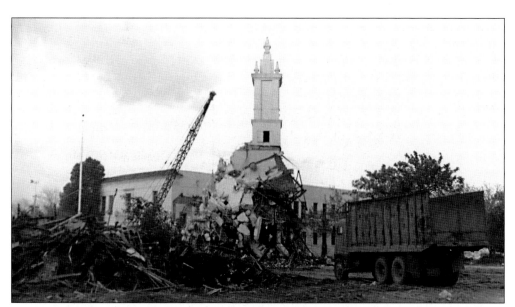

After 41 years, the Christian Brothers High School fell prey to the wrecking ball in April 1965. It was replaced by the Bishop Monogue High School for girls. Since 1990, that building has been leased by the state as part of the DMV complex. (Courtesy of SAMCC.)

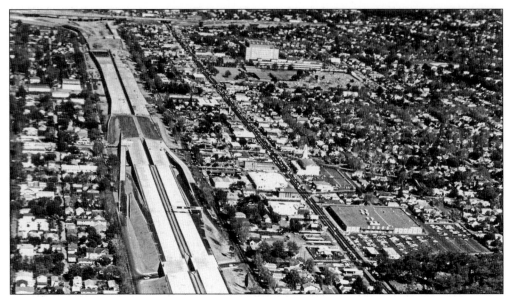

In 1966, the W/X segment of Interstate Highway 80 was under construction. The elevated freeway became the northern border of Curtis Park. (Courtesy of SAMCC.)

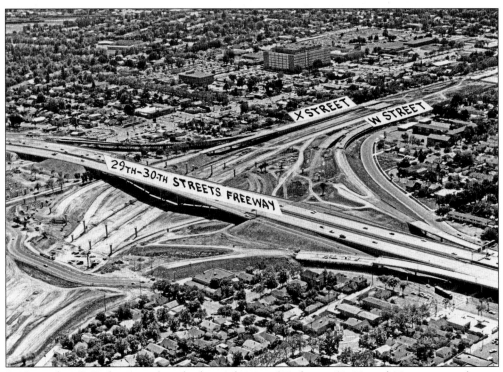

In November 1967, the giant cloverleaf interchange of Highways 50, 80, and 99 nears completion. (Courtesy of SAMCC.)

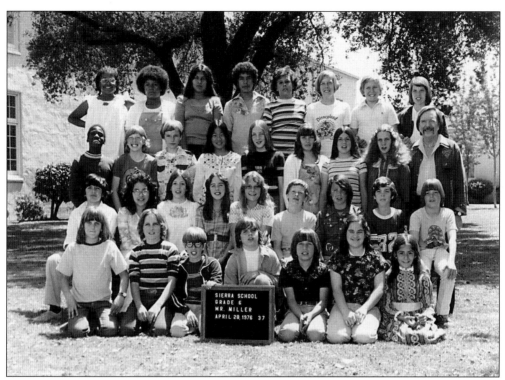

The last class of Sierra School graduates pose on the front lawn. (Courtesy of Trey Bonetti.)

In 1976, both the Bret Harte and Sierra School were closed under the earthquake safety strictures of the Field Act. Bret Harte was demolished and rebuilt soon after. Sierra School, here with a closure notice on its front door, was slated for demolition without replacement. (Courtesy of SAMCC.)

In 1979, Curtis Park neighbors proposed that the Sierra School building become a neighborhood center for cultural and educational activities. They created the Sierra Curtis Neighborhood Association (SCNA), initially called the Sierra School Neighborhood Association. After a long struggle, SCNA saved the building. The school sign was recently returned to SCNA and is on display. (Courtesy of SAMCC.)

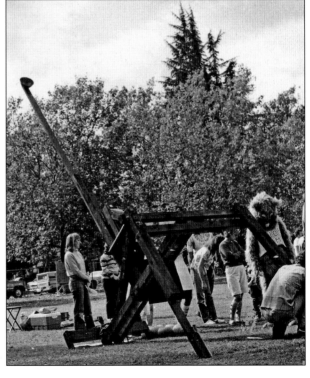

A zany SCNA tradition of the early 1980s was the annual pumpkin toss contest, which quickly spawned a local arms race. Neighbors looked on with awe, even a little trepidation, at the latest round of inventive contraptions. (Courtesy of SCNA.)

Is it a bird? A soccer ball? No, it's a pumpkin lofted nearly into orbit. (Courtesy of SCNA.)

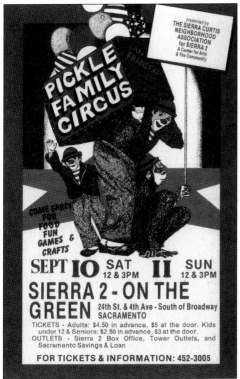

One popular early fund-raising activity of SCNA was the annual performance by the San Francisco Pickle Family Circus. (Courtesy of SCNA.)

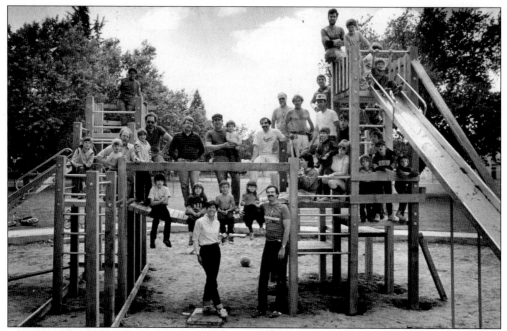

Here are some of the neighbors who built up community sweat equity by helping construct the Sierra Green playground. Many of the SCNA projects during the early years relied on volunteer helpers from the neighborhood. (Courtesy of SCNA.)

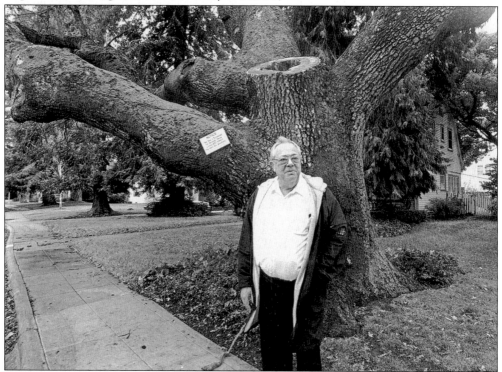

In 1995, James McDowall stands in his front yard with the Curtis Ranch oak behind him. A notice on the tree announces that it is scheduled for removal.

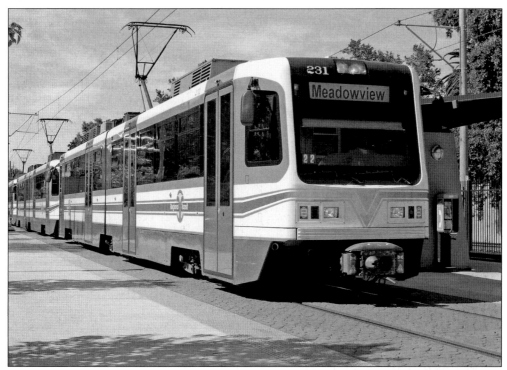

Opened in September 2003, the vanquished streetcar was reincarnated in the Southline light rail extension. The line, following the Union Pacific (Western Pacific) right-of-way, has three stations in Curtis Park—Broadway, Fourth Avenue, and City College.

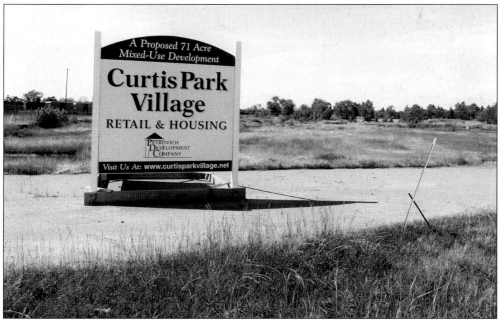

In 2003, Paul Petrovich purchased the railyard property from the Union Pacific Railroad Company. Petrovich allayed one of the greatest sources of community concern about development by promptly promising a complete toxic cleanup for the entire property.

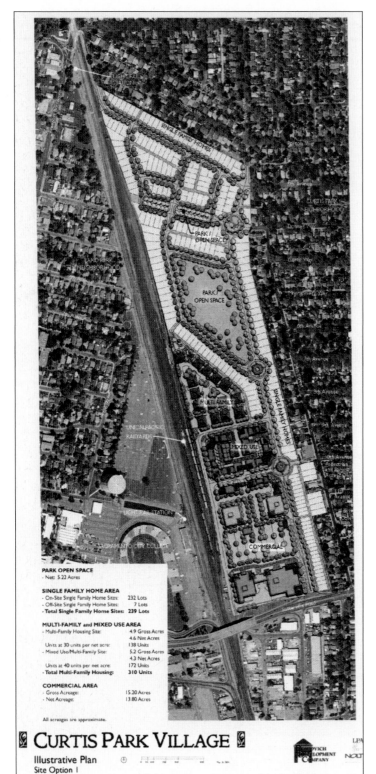

PARK OPEN SPACE
- Net: 5.22 Acres

SINGLE FAMILY HOME AREA
- On-Site Single Family Home Sites: 232 Lots
- Off-Site Single Family Home Sites: 7 Lots
- **Total Single Family Home Sites: 239 Lots**

MULTI-FAMILY and MIXED USE AREA
- Multi-Family Housing Site: 4.9 Gross Acres
 4.6 Net Acres
 Units at 30 units per net acre: 138 Units
- Mixed Use/Multi-Family Site: 5.2 Gross Acres
 4.3 Net Acres
 Units at 40 units per net acre: 172 Units
- **Total Multi-Family Housing: 310 Units**

COMMERCIAL AREA
- Gross Acreage: 15.20 Acres
- Net Acreage: 13.80 Acres

All acreages are approximate.

CURTIS PARK VILLAGE

Illustrative Plan
Site Option 1

This is an early site option for the Curtis Park Village proposal for development of the Curtis Park railyard. Petrovich has pledged to sell single family home lots in small blocks and, subject to design restrictions, to blend with the character of the surrounding neighborhood.